COLOR HARMONY
LOGOS

ROCKPORT

More Than 1,000 Colorways for Logos that Work

COLOR
HARMONY
LOGOS

ROCKPORT PUBLISHERS

MINE™

© 2006 by rockport publishers, inc.

First published in the USA by Rockport Publishers, a member of Quayside Publishing Group.

33 Commercial Street
Gloucester, Massachusetts 01930-5089
Telephone: (978) 282-9590
Fax: (978) 283-2742
www.rockpub.com

Printed in Singapore

ISBN 1-59253-244-6
10 9 8 7 6 5 4 3 2 1

Design: MINE™
www.minesf.com

CONTENTS

the essence of color

the character of color

case studies

the making of color

introduction

In a designer's craft, logos represent a special achievement. They are the most succinct and compact vehicles we use to communicate complex messages. They must embody select and specific qualities that connect with and linger in the memories of their intended audiences. They must be thoughtfully conceived, expertly crafted, employ appropriate and supportive typography, and be imbued with a color sense that resonates with their viewers. It is perhaps this final aspect that can prove most elusive.

Color is highly subjective. What is individually pleasing to one person may elicit only a neutral response in another. How many times, for example, have you been asked to use the CEO's favorite color in the company's logo? How many times have you observed designers propose logo colors based on the latest trend or on their own personal preference?

While there's no way to anticipate (and little reason to accomodate) arbitrary tastes, there are certain colors and combinations that have come to represent particular attributes. Knowing and understanding these attributes can help you be more effective when selecting colors for your logo projects.

This book explores the complex issue of color selection for identity in a unique and practical format. We begin with the basics, refamiliarizing ourselves with the color wheel, its revealing geometries, and the color schemes derived from its construction. With these as our guides, we then explore the various moods associated with color. These color attributes are divided among twenty-six chapters, each of which contains numerous unique palettes, organized in a range of color schemes.

Within each chapter are demonstrated multiple color combinations actually applied in the context of a logo. At a glance you'll be able to see real world applications of the concepts discussed. The art for these logos is provided on the enclosed CD, allowing you to conduct your own experiments — using our colors or your own — to compare the effect color has on the nature and character of a logo.

While you would typically specify spot colors for use in logos, the colors shown in this book are created from CMYK builds. They are not intended to be *exact* color recommendations. Rather, they are intended for inspiration and experimentation. Constructed from a base of 107 colors and organized by attribute into nearly 1,200 different palettes, this *Color Harmony* guide will serve as a useful reference as you develop evocative, attention-grabbing logos.

selecting color

When it comes to the application of color to logos, several consideratons must be weighed. First among them is the general (but recently declining) requirement that a logo should work in one color. Typically, one color means black, and is based on economy more than any color theory. While it is important to consider what happens to a logo when it is photocopied, faxed, or applied in one-color situations (such as newspapers or silk-screened on a t-shirt), the one-color rule is slowly becoming less applicable. We are increasingly relying on paperless document distribution, and color desktop printing is practically ubiquitous. If your multicolored logo needs to work in a single color, be sure to select colors that are sufficiently different in value to allow for one-color reproduction.

Another consideration is utility. How easy will it be to implement the color scheme you've selected for your logo? A three-color logo, for example, requires a significant commitment when producing printed materials. Complex, three-color designs generally incur more cost when printing, and may limit your flexibility when selecting accent colors in your designs. To mitigate this, colors from the logo itself are often used as major colors in the applied design (this is also true of two- and one-color designs). When selecting colors for a logo, it's important to anticipate its final application.

In addition to these practical considerations, color should be considered an effective tool for storytelling. Color communicates a wealth of feelings, moods, and circumstances. It's no accident that red and yellow are almost ubiquitously used in branding fast food franchises, or that blue is so frequently associated with health care. Careful thought has been given to the effect these colors have

on the human imagination. By understanding the moods that color can promote, a logo can become an effective ambassador for the nature and psychology of the entity it represents.

Sometimes color choices are obvious — such as when you're designing a logo for a company with a color in its name, or when the subject of the logo is naturally synonmous with a color (i.e., blue for water). In other instances, color selection presents more of a challenge. That is where *Color Harmony: Logos* can help.

To aid in the selection of colors for logos, this book presents a variety of resources. First, we'll break down some basic color theory, analyzing the structure of the color wheel and the harmonious color relationships created within its various geometries. Because these relation-ships are geometric, they are used to identify the natural realtionships among an infinite variety of specific hues. Next, we'll explore a range of twenty-six moods, and how color plays a critical role in their communication. Each mood includes a variety of specific palettes in different schemes, extracted from the master palette on the fol-lowing page.

Armed with an understanding of the theoretical relation-ship of colors, and an appreciation for the power of color to elicit specific moods, you'll have the tools you need to create memorable, appropriate logos that make effective use of color.

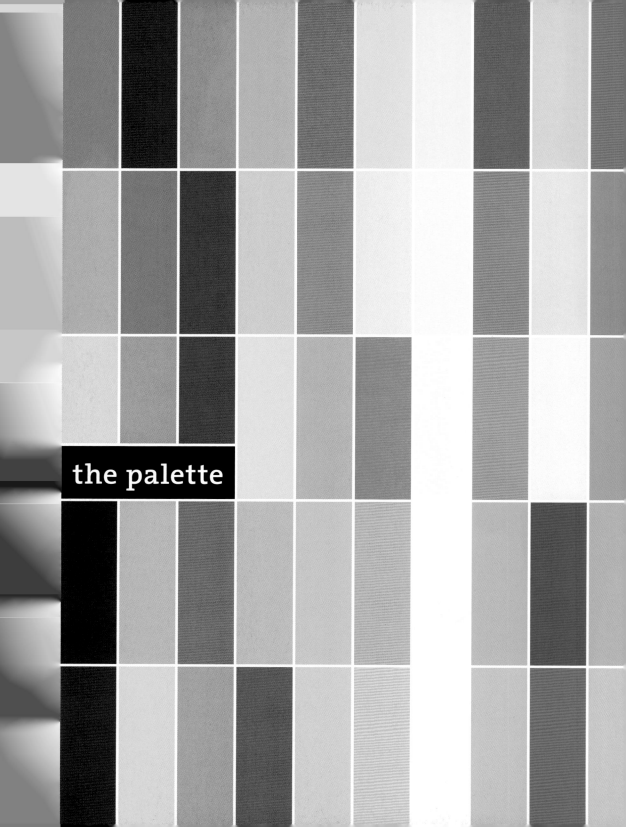

the palette

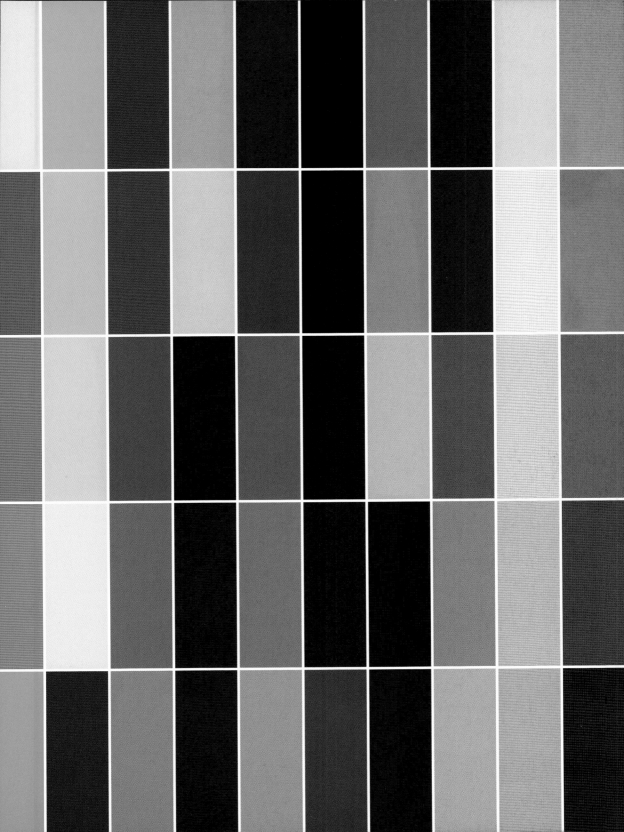

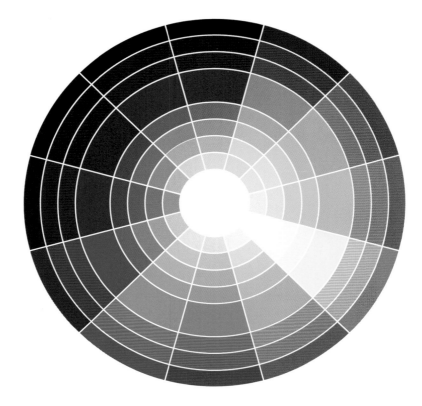

the color wheel

The color wheel organizes the palette from the preceding page (less the blacks and greys) into twelve segments, representing the full chromatic spectrum. Depicted this way, it serves as a tool that helps us visualize the varied harmonious relationships that exist among its hues and segments — each of which can be extracted and combined to create a range of color schemes. To understand these combinations, we must first understand how the color wheel is constructed.

The color wheel is anchored by three primary colors — red, yellow, and blue — which articulate an equilateral triangle within the wheel. Complementing these colors are three secondary hues — green, violet, and orange. These form a second, opposing equilateral triangle. This geometric color structure is further augmented by a tertiary palette of six mixed hues, derived by combining the primary and secondary palettes. Together, these twelve segments create a complete, graduated color wheel.

In the color wheel shown above, primary, secondary, and tertiary colors are shown in the thicker ring of swatches at their full *saturation* (the brightness of a color). Below these, moving inward toward the center of the wheel, are *tints* of those hues. Tints are created by adding white to the base color. The more white is added, the lighter the tint or *value* (the relative lightness or darkness) of the color. Pink is a tint of red, ivory is a tint of yellow.

Conversely, by adding black or grey to the saturated color, darker values, called *shades*, are produced. These are shown in increments, moving outward toward the perimeter. Maroon is a shade of red, gold is a shade of yellow.

primary colors

Primary colors form the basis of the color spectrum. In theory, these colors can be mixed with one another to create all other colors. In practice, this is not strictly true. Inscribing an equilateral triangle within the color wheel, the primary colors of red, yellow, and blue establish the basis by which secondary and tertiary colors are defined.

secondary colors

Secondary colors fall on the points of a second equilateral triangle, positioned opposite the first. Also called complementary colors, they are formed by mixing equal parts of the primary color points they bisect:

- orange = red + yellow
- green = yellow + blue
- violet = blue + red

tertiary colors

The segments between the primary and secondary color segments are occupied by a range of tertiary hues created by mixing one primary and one secondary color. Tertiary colors are named for the two colors used to created them, with the primary color being named first (for example, blue-green, or red-orange).

Understanding the relationship between primary, secondary, and tertiary color positions forms the basis for making color selections and creating unique and interesting palettes. The geometry of the color wheel provides a useful tool for guiding and testing your color choices from a practical standpoint. It can be used, for example, to help ensure a harmonious balance of warm and cool colors (roughly divided between left and right on the color wheel), to anticipate combinations that will provide appropriate contrast, or to build sophisticated color palettes within any one of the ten basic color schemes. Those schemes are defined and explained on the following pages.

monochromatic

Monochromatic color schemes use a single hue, in combination with one or more of its tints or shades. Low in contrast, but nonetheless authoritative, these palettes can be both balanced and soothing.

primary

Primary color schemes are simply those that combine the pure values of the red, yellow, and blue primaries. Red and blue are often used to balance each other out, while, for logos, yellow is often used as an accent.

analagous

Analogous color schemes are derived from any three adjacent hues (or their tints or shades) on the color wheel. One color is dominant, with the others used as accents. Analogous color palettes are similar in feeling to monochromatic schemes, but offer more depth and subtlety.

pros:
There's no guess work with these color schemes—simply pick a color and go.

pros:
Basic and bold, a primary color scheme is perhaps the easiest to select.

pros:
Simple to create, these palettes have unity and consistency.

cons:
Notice how a monochromatic color scheme lacks the diversity of hues that other color schemes exhibit.

cons:
The even spacing of these colors from each other on the color wheel creates a harmonious but unrefined palette.

cons:
Low contrast limits the versatility of these otherwise effective palettes.

tips:
The highest amount of contrast between shades and tints of a hue utilize the full potential of a monochromatic color scheme.

tips:
Primary color schemes are good starting points for discovering richer, more interesting combinations.

tips:
Though technically adjacent, it's best to avoid mixing warm and cool colors in these palettes.

clash

Clashing color schemes are those which pair a first color with a second to the left or right of its color wheel complement. Clashing color schemes can comprise just two colors for maximum impact and contrast.

complementary

Complementary color schemes pair direct opposites on the color wheel. They provide effective contrast, and can be used to complete or neutralize each other. Pairing a warm color like orange with a cool color like blue, for example, is an effective way of creating a balanced yet dramatic mood.

split complementary

Split complementary palettes are created by combining a color with the hues on each side of its compliment. These combinations still allow for high contrast, but with more subtlety than a direct complementary combination.

pros:
These color schemes provide high contrast and make a bold statement.

pros:
Colors are easy to select, and provide diversity and harmony simultaneously.

pros:
These combinations are nuanced, but don't sacrifice overall impact.

cons:
If your clashing palette needs to work with a third or fourth color, you could be in for a color nightmare.

cons:
As with the clashing palette, too much contrast can be overwhelming. Sometimes these vibrate visually.

cons:
These combinations can become complex. A discerning eye is required to be effective.

tips:
Use clashing palettes sparingly; a little goes a long way.

tips:
Choose one color as your dominant color, and use the other as an accent.

tips:
Use the two split complements as accents to the single, dominant color.

neutral

Neutral color schemes are a mixture of a hue and its complement, or a hue and black. Calm and sophisticated, this color scheme is common in corporate logos, while more vibrant neutral tones are making their way into packaging for organic goods.

secondary

The secondary set of hues in the color wheel — green, violet, and orange — comprise this color scheme. Used at full saturation, secondary color schemes can be very energetic or traditional, depending on which colors are accentuated.

tertiary triad

Combining either red-orange, blue-violet, and yellow-green or yellow-orange, blue-green, and red-violet, will create a tertiary color scheme. Triad schemes use colors of equal purity.

pros:
Nonthreatening and stable, neutral color schemes have a calming effect without being perceived as simple.

pros:
Just as bold as a primary color scheme, the choice of secondary colors can be less expected.

pros:
Tertiary color schemes are vibrant yet comfortable.

cons:
Neutral color schemes can appear dirty and lack the excitement of more saturated color schemes.

cons:
Secondary color schemes are difficult to combine with other schemes.

cons:
This color scheme is perhaps the least recognizable of all the color schemes and can be viewed as unexpected.

tips:
Combine neutral colors within other color schemes for a more sophisticated palette.

tips:
This color scheme is most effective when one color is dominant or there is a broad range of value between all three colors.

tips:
Tertiary triad color schemes can serve as a second or third group of colors within a larger collection of colors.

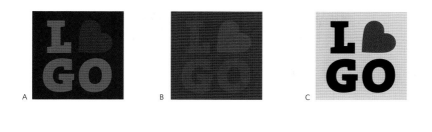

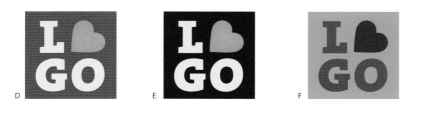

color relationships

Colors relate to one another as do actors in a play. The overall performance is affected by combinations of large and small roles. When colors are very similar in contrast (whether relative in hue or other aspect) there is no protagonist, resulting in an indescernable visual scene (A). One way to test for this is to convert your image to grayscale (B) — if the colors are too close in value they lose their definition, regardless of hue. Balance of contrast creates dimension; certain hues stand out while others take on a supporting role (C).

Colors are also affected by those surrounding them. The exterior color creates a cast upon those colors it adjoins (D, E), seemingly changing their appearance. Beware also of using analogous colors with one complementary color (F). Imagine a chorus singing in harmony — then enter a solo voice in a different key. The result is a dramatic, vibrating entrance, sometimes more startling than impressive.

In this book, we have chosen to address color relationships through a seres of adjectives. Each color palette represents a thematic exploration designed to communicate the character associated with each attribute.

Below each logo in this book are a set of numbers which correspond to the 107 different swatches utilized to depict each chapter's theme. The CMYK values for each numbered swatch have been diagramed in the process color chart at the back of the book, page 152.

character

POWERFUL

What it's about:

The go-to color for communicating power has always been red. From propaganda posters to power ties, this sanguine hue has a way of capturing our attention. Not for the shy, red says "I want to be noticed." It burns with fiery passion, and pulses with emotional intensity. It is the color of desire, and has long been associated with courage. Red figures prominently in national flags, and is by far the most popular and versatile color in logo design.

What it's good for:

Large, established businesses
Architects and other creative professional services
Arts organizations
High performance sports and equipment
Fast food

What to watch out for:

Red can also be associated with lust, danger, debt, anger, and blood.

1 **DESIGNER:** MIRES **CLIENT:** LA STREET GEAR HOCKEY
2 **DESIGNER:** GARDNER DESIGN **CLIENT:** LITTLE RED DEVILS
3 **DESIGNER:** CHASE DESIGN GROUP **CLIENT:** TOTH ADVERTISING

1

2

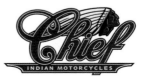

3

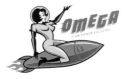

M 4

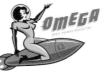

M 4, 6

M 2, 4

M 3, 7

M 2, 4, 6

M 1, 3, 4

M 2, 4, 7

P 4, 36, 68

P 6, 38, 70

P 4, 34, 67

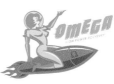

C 4, 52

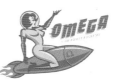

C 5, 50

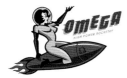

C 1, 49

C 7, 55

C 3, 54

C 2, 50

SEE PROCESS COLOR CHART ON PAGE 152 FOR CMYK VALUES

A = ANALAGOUS C = COMPLEMENTARY CL = CLASH M = MONOCHROMATIC

N = NEUTRAL P = PRIMARY S = SPLIT SC = SPLIT COMPLEMENTARY

A 5, 12, 92

A 6, 12, 92, 95

A 2, 14, 92, 94

A 4, 12, 20

A 7, 11, 12, 22

SC 4, 44, 60

SC 1, 44, 60

SC 7, 45, 59

SC 2, 44, 57

SC 5, 44, 61

S 1, 41, 58

SC 4, 41, 62

SC 4, 47, 63

SC 2, 46, 60

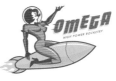

C 7, 41

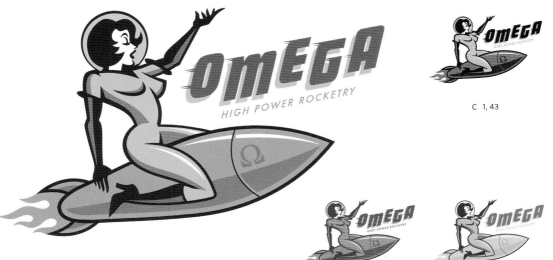

C 1, 43

A 3, 13, 20

C 3, 57

C 4, 44

S 6, 44, 57

S 6, 42, 63

N 1, 4

N 3, 4

N 1, 8

N 4, 101, 105

N 4, 98, 104

N 4, 102, 97

RICH

What it's about:

With richness comes abundance, and with that abundance, fullness. Characterized by full, dark colors — from warm reddish browns and full-bodied burgundies, to deep blues and greens — rich colors communicate status, tradition, and indulgence. Never ostentatious, they are sophisticated in tone, and evoke the textures and flavors of luxury and comfort with understated elegance.

What it's good for:

Gourmet products and experiences
Exclusive clubs and organizations
Artisanal products
Prep schools and colleges
Anything else for which tradition is central

What to watch out for:

Rich colors suggest opulence and expense, so be sure you don't alienate your audience.

1 **DESIGNER:** THOMAS VASQUEZ **CLIENT:** KINDRED KITCHENS
2 **DESIGNER:** SOLOFLIGHT DESIGN STUDIO **CLIENT:** TALIA FOODS
3 **DESIGNER:** STEPHEN O'CONNOR **CLIENT:** DALE BUELOW

1

2

3

M 1, 3, 8

M 1, 5, 8

M 2, 6, 8

P 1, 33, 64

P 2, 34, 66

P 3, 35, 65

C 1, 8, 51

C 1, 18, 56

C 2, 18, 56

C 3, 49, 56

C 2, 16, 51

C 1, 26, 56

A 16, 18, 89

A 2, 82, 96

A 16, 84, 90

A 16, 17, 89

SEE PROCESS COLOR CHART ON PAGE 152 FOR CMYK VALUES

A = ANALAGOUS C = COMPLEMENTARY CL = CLASH M = MONOCHROMATIC

N = NEUTRAL P = PRIMARY S = SPLIT SC = SPLIT COMPLEMENTARY

A 2, 16, 91

A 2, 16, 94

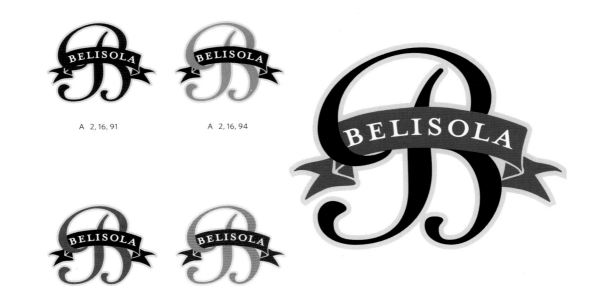

A 2, 16, 25

A 10, 24, 27

SC 1, 47, 57

SC 1, 48, 58

SC 1, 56, 63

SC 1, 45, 64

SC 2, 47, 61

SC 3, 48, 63

S 23, 42, 57

S 2, 46, 64

S 1, 47, 59

CL 1, 16, 43

CL 1, 46, 48

CL 1, 16, 62

CL 3, 16, 57

CL 2, 51, 56

N 1, 48, 54

N 1, 49, 56

N 2, 97, 103

N 3, 16, 50

N 17, 97, 100

N 1, 98, 104

N 3, 97, 102

ROMANTIC

What it's about:

The central color in most romantic palettes is pink. And while pink is a lightened hue of red, it would be a mistake to think of pink as in any way watered-down. While pink can be soft, gentle and passive, it is increasingly being used in more assertive applications. Combined with red, it can be sumptuous, even lustful. With green or blue, it takes on a more playful tone. No longer the exclusive realm of the feminine, pink is an under-appreciated color that makes a sensitive, yet confident statement.

What it's good for:

Fashion for women and self-assured men
Products and services that cater to younger children
Cosmetics, beauty products, and spas
Anyone looking to stand out in a traditional industry

What to look out for:

Be aware that pink ribbons are the symbolic emblem of breast cancer survivors. The pink triangle — first introduced by the Nazis to identify homosexuals — is now an established symbol of the gay community.

1 **DESIGNER:** DESIGN AND IMAGE **CLIENT:** GLO

2 **DESIGNER:** SIMON & GOETZ DESIGN **CLIENT:** FRANK KUHLMAN

3 **DESIGNER:** GLITSCHKA STUDIOS **CLIENT:** ZEN CAST

1

2

3

M 6,8 M 3,6 M 3,7 M 3,6,8

M 1,6,8 M 1,3,6 P 5,38,70 P 7,37,67

P 8,40,72 P 6,39,72 C 6,54 C 8,54

C 5,51 C 7,55 C 6,51 C 8,49

SEE PROCESS COLOR CHART ON PAGE 152 FOR CMYK VALUES

A = ANALAGOUS C = COMPLEMENTARY CL = CLASH M = MONOCHROMATIC

N = NEUTRAL P = PRIMARY S = SPLIT SC = SPLIT COMPLEMENTARY

A 6, 86, 94 A 8, 87, 96 A 6, 15, 94 A 7, 14, 95

A 7, 16, 93 A 5, 15, 96 A 6, 14, 22 A 5, 16, 23

A 7, 16, 22 A 8, 12, 23 SC 6, 46, 62 SC 6, 45, 63

SC 7, 47, 63 SC 3, 46, 64 SC 8, 44, 61 SC 7, 47, 59

SC 6, 43, 57

S 5, 43, 64

S 7, 47, 64

S 7, 44, 63

S 8, 48, 62

CL 4, 43

CL 5, 59, 66

CL 6, 46, 66

CL 8, 61

N 6, 9

N 7, 11

N 5, 98, 100

N 6, 97, 99

VITAL

What it's about:
Vitality is often expressed as vigor: life energy. Rich, sanguine reds play a critical role in establishing the pulse of this palette. Whether paired with blue-green complements for a fresh, youthful look, or flanked by hues of red and orange for a warmer, more comforting feel, the vital palette courses with warmth and energy. At its heart, colors are bright and saturated—without being garish or loud. These colors exude a feeling of health and well-being. Think rosy cheeks and vegetable juices, and you'll have some idea of what this palette is about.

What it's good for:
Advertising and merchandising applications, especially those where a healthy, robust attitude is important.

What to look out for:
Red and green can look "Christmasy" very quickly. Pay attention to hues to avoid unintended associations.

1 DESIGNER: RICHARD BROCK MILLER MITCHELL AND ASSOCIATES CLIENT: YOUNG PRESIDENT'S ORGANIZATION
2 DESIGNER: CHASE DESIGN GROUP CLIENT: COLUMBIA PICTURES
3 DESIGNER: PLUMBLINE STUDIOS CLIENT: CALLAN FITNESS

1 2 3

M 12

M 12, 15

M 10, 12

M 12, 16

M 9, 12, 15

M 10, 12, 14

M 9, 11, 12

T 12, 44, 76

T 12, 42, 73

T 14, 46, 78

T 12, 42, 79

C 12, 60

C 15, 58

C 13, 57

C 13, 61

C 12, 63

SEE PROCESS COLOR CHART ON PAGE 152 FOR CMYK VALUES

A = ANALOGOUS C = COMPLEMENTARY CL = CLASH M = MONOCHROMATIC

N = NEUTRAL S = SPLIT SC = SPLIT COMPLEMENTARY T = TERTIARY

A 4, 12, 92

A 5, 11, 94

A 4, 12, 20

A 4, 15, 20

A 7, 13, 20

A 8, 10, 22

A 12, 20, 28

A 14, 18, 32

SC 12, 52, 68

SC 12, 50, 70

SC 12, 54, 71

SC 10, 55, 68

SC 9, 52, 68

SC 13, 51, 70

SC 11, 50, 68

S 5, 52, 65

S 12, 56, 70

S 11, 51, 66

C 12, 51

C 13, 49

C 15, 66

C 11, 65

N 12, 101, 106

N 9, 16

N 12, 9

N 12, 98, 104

N 12, 98, 102

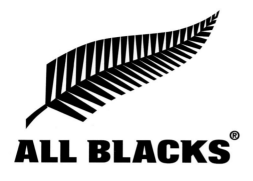

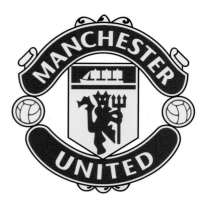

TEAM COLORS

Of all categories of identity, sports teams make the most considered and critical use of color. Not only must the colors work well to give life to the team logo, they're used to identify fellow and opposing team members on the field or court. Fans also choose to identify themselves by wearing their team's colors to games, and by purchasing billions each year in branded merchandise.

For many teams, color has become synonymous with their identity. The New Zealand All Blacks, the Cincinatti Reds, and the Cleveland Browns all take their names from the colors that represent them. In fact, the Browns' logo is simply an image of their helmet, presented in their signature brown and orange. Similarly, Oakland Raiders fans refer to their team simply as "The Silver and Black."

In college sports, UC Berkeley's players are know as the "Golden Bears," while Dartmouth's are nicknamed "Big Green." Berkeley's official colors, by the way, are "California Gold" and "Yale Blue," and "Dartmouth Green" is one of the official colors of the Oklahoma state flag.

Some team colors are dictated by the team's history, location, or cultural heritage. The Fightin' Irish will always use green as representative of their ethnic heritage, and the Green Bay Packers — named for their locale, but now identified by their colors — will forever be wed to their distinctive green and gold. For those not bound by the suggestive limitations of their names, aggressive, powerful colors are generally preferred. High-contrast combinations like the orange and black (employed by the Cincinnati

Bengals, San Francisco Giants, and Philadelphia Flyers) are popular because of the aggressive posture they promote. Others, like green and gold, green and blue, or blue and yellow, offer an invigorated, optimistic palette. But by far, the most popular color in sports is red.

As discussed in the earlier chapter on power, red is an aggressive, vital color — full of confidence and bravado. It is also the "winningest" color in sports.

According to British anthropologists Russell Hill and Robert Barton of the University of Durham, in evenly matched contests, the team or contestant wearing red is generally more likely to win. The pair studied the outcomes of the Euro 2004 International soccer tournament, as well as the results of the summer

Olympics. In each instance, red was more likely to prevail, while blue was the least likely to emerge the victor.

CLOCKWISE FROM TOP LEFT:
DESIGNER: DAVE CLARK CLIENT: NZRU
CLIENT: MANCHESTER UNITED
DESIGNER: MLS CREATIVE SERVICES
CLIENT: MAJOR LEAGUE SOCCER
DESIGNER: JOE BOSACK CLIENT: KEYSTONE BASEBALL
DESIGNER: CHRISTOPHER SIMMONS CLIENT: RED DEVILS
DESIGNER: RICKABAUGH GRAPHICS
CLIENT: THE OHIO STATE UNIVERSITY
CLIENT: MAJOR LEAGUE BASEBALL
CLIENT: NATIONAL HOCKEY LEAGUE
CLIENT: MAJOR LEAGUE BASEBALL
DESIGNER: VERLANDER DESIGN
CLIENT: NATIONAL FOOTBALL LEAGUE

FUELING THE FIRE

Red, yellow, and orange are the clearly favored colors in America when it comes to fast food branding; Burger King, McDonalds, Wendy's, Carl's Jr., Sonic, In-N-Out, and Pizza Hut all employ both yellow and red in their logos. With such a ubiquitous color vocabulary, how does one franchise differentiate from another? The answer is a matter of subtleties.

Take, for example, the revitalization of the Burger King brand. The famous yellow buns that literally sandwich the red "Burger King" logotype (above) hadn't seen an update since their inception in 1969. After a thirty-year run, the company turned to Sterling Brands to give new life to the familiar trademark. "We found that you could put any two words inside the buns and consumers would still recognize it as Burger King," says Marcus Hewitt, creative director at Sterling Brands and the lead designer on the project, "but the logo looked tired and didn't reflect the energy and dimension they wanted to communicate."

Hewitt and Sterling Brands' design director, Stephanie Krompier, knew they had to preserve the identity's familiar elements (and colors), so they concentrated on reinterpreting these attributes. The type kept its hefty character, but was chiseled with a few sharp edges, and enlarged so that it burst out of the bun (Burger King is the home of the Whopper® after all!). The bigger type also established red as the dominant identity color, whereas in the original logo, the red and yellow are evenly balanced and less dynamic.

Most dramatic, however, was the introduction of a color not often associated with food products or restaurants — blue. Color psychologists have long asserted that blue is the most unappetizing of all the colors, yet in the case of Burger King, it perfectly complements the overall warmth of the identity, and acts as a surprising differentiator among its look-alike competitors. By framing the logo in an unexpected swash of bright cobalt blue, the traditional red and yellow (both of which were subtly brightened) are propelled forward — adding new dimension and dynamism to the identity.

DESIGNER: STERLING BRANDS **CLIENT:** BURGER KING

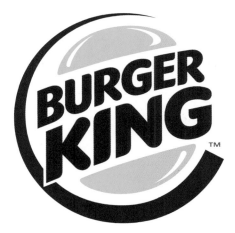

GOLDEN GATE HELICOPTERS

GOOD AS GOLD

Golden Gate Helicopters is a premier, San Francisco Bay Area-based provider of premium helicopter services. Named for the city's famed landmark bridge, the color selections for this logo seemed obvious from the beginning (it's tough to avoid using gold in a logo that has "Golden" as part of its name!). If you've never seen it, the Golden Gate Bridge isn't really golden at all, but a deep, brownish red. It's an unmistakable color, and one that you don't see duplicated often—if ever.

In developing the mark, we wanted to make reference to this iconic structure, and its signature color, without duplicating it exactly. We wanted to play up the nostalgia factor, without being dated or trite. By selecting a red and gold within an analogous color range, the color harmony created here evokes a rich, classic look that also feels contemporary and up-to-date. In a sense, the red anchors the mark to its historical reference, while the brighter gold points forward, propelling the logo into the present.

As important as the colors of the logo itself is the color context in which it lives. For this, we went through countless rounds of revisions, making minute tweaks to the supporting palette to achieve just the right effect. The result is a supporting palette of six colors: A traditional deep blue adds stability and prestige to the palette, as does the "British Racing Green" (which also adds a sporty edge to the system). Both of these are complements to the principal logo colors. A rusty orange adds a touch of warmth to the color scheme. Three softer accent colors complete the palette, composed of a heather green, sky blue, and a soft, mellow cream—all of which are based on samples of the landscape surrounding the Golden Gate as observed on an aerial tour.

DESIGNER: MINE CLIENT: GOLDEN GATE HELICOPTERS

GOLDEN GATE HELICOPTERS

IDENTITY GUIDELINES

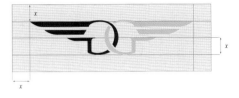 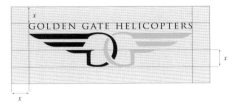

Identity Color	PMS	CMYK	RGB
	187	0, 100, 79, 20	201, 0, 22
	130	0, 30, 100, 0	255, 179, 0

Secondary Color			
	717	0, 58, 100, 13	222, 93, 0
	653	100, 62, 0, 20	10, 49, 122
	555	75, 0, 60, 55	29, 78, 49

Accent Color			
	577	26, 9, 37, 9	186, 206, 153
	658	50, 17, 4, 0	127, 172, 202
	608	0, 2, 27, 2	250, 245, 180

TROPICALPIX

SEA OF COLOR

TropicalPix is a Singapore-based stock photography agency specializing in photos of unique tropical locations. Their images are widely published in surf, travel, and in-flight magazines around the globe. Recently, the fledgling agency turned to Singapore's Manic Design to refresh their identity.

From the start, Karen Huang, who runs Manic, knew that color would play a critical role in the identity, as both the name and the focus of the business immediately suggest vivid, tropical colors. "The client's photos were a natural starting point when deciding how to use color in the logo," she says. "Their images are characterized by intensely saturated colors that come together to form the palette of the tropics."

Manic envisioned an identity that employed colors with credibility and personality. Specifically, the designers wanted to avoid interpretations such as the stylized hues of Hawaiian shirts or bright, primary colors (which Karen says she avoids as a matter of course). Instead, she created a grid of tropical images, "a kind of real-world manifestation of Duffy's Bahamas

identity," then sampled colors directly from the photos. The resulting palette echoes the reds, oranges, and yellows of flaming sunsets, the aqua blues of rising surf, and the chartreuses and jades of the verdant tropical landscape. "Selecting the perfect color was more a matter of communicating the clients' character than driving home the tropical theme," says Karen, explaining that the word tropical already effectively communicates that aspect of TropicalPix's business. After much deliberation, the designers ultimately recommended a light blue that she describes as "the color of the sea, basking in bright yellow sunlight."

Although Karen asserts that blues are "inherently boring," the particular hues of the two-tone solution she selected work because they bring a light, airy, vacation feel to the design; despite being relatively pale, the colors also manage to be conspicuous.

DESIGNER: MANIC DESIGN **CLIENT:** TROPICALPIX

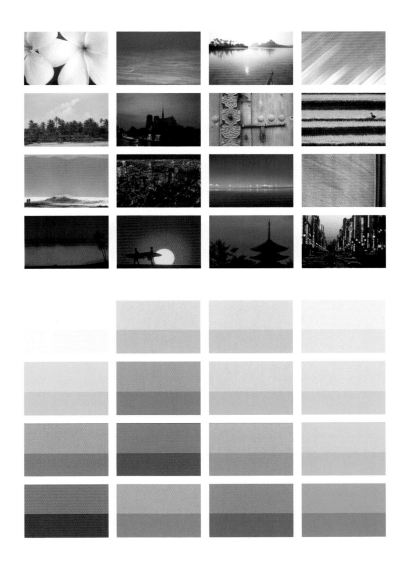

Above:
Colors were sampled from TropicalPix's library of images
(top grid) to create its supporting color palette (bottom grid).

EARTHY

What it's about:

As the name suggests, earthy palettes are based on rich, natural hues borrowed from the earth itself. Sharing much in common with the "vital" colors discussed earlier, these combinations are infused with healthy, rustic hues of red. Characterized by their richness and depth, these colors imply a natural, holistic sense of balance and connectedness. Because they are drawn from natural sources, there is an innate sense of comfortable familiarity associated with this palette that also carries with it a feeling of honesty and reality.

What it's good for:

Retreats and Spas
Camps
Outdoor education

What to look out for:

These color schemes aren't about drama. The overall warmth that pervades this palette is more comforting than inspiring.

1 DESIGNER: SABINGRAFIK, INC. CLIENT: FOUND STUFF PAPERWORKS
2 DESIGNER: HENDERSON TYNER CO. CLIENT: LITTLE THEATER
3 DESIGNER: MIRES CLIENT: SHEA HOMES

M 10, 15

M 9, 13

M 11, 16

M 9, 10, 13

M 10, 11, 15

M 10, 11, 14

T 10, 42, 74

T 9, 41, 74

C 10, 58

C 9, 59

C 11, 59

C 10, 57

A 3, 10, 91

A 2, 11, 90

A 3, 10, 89

A 1, 13, 91

SEE PROCESS COLOR CHART ON PAGE 152 FOR CMYK VALUES

A = ANALAGOUS C = COMPLEMENTARY CL = CLASH M = MONOCHROMATIC

N = NEUTRAL S = SPLIT SC = SPLIT COMPLEMENTARY T = TERTIARY

NOTE: SOME LOGOS APPEAR TO HAVE FIVE DIFFERENT COLORS, WHEN THEY ACTUALLY ONLY HAVE TWO OR THREE, DUE TO THE EFFECT OF ALTERING THEIR TRANSPARENCY.

A 2, 10, 18 A 3, 9, 19 A 10, 20, 27 A 11, 19, 26

A 1, 10, 21 A 9, 21, 25 A 13, 18, 25

SC 10, 50, 66 SC 9, 51, 66 SC 11, 52, 67 SC 10, 49, 68

SC 10, 50, 67 SC 11, 49, 66 S 10, 51, 70 S 11, 50, 69

S 11, 53, 68

S 10, 54, 58

CL 10, 51

CL 11, 54

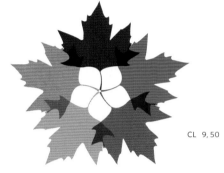

CL 9, 50

CL 9, 66

CL 10, 70

N 12, 103

N 11, 99

N 10, 98, 101

N 9, 97, 100

N 11, 100, 102

N 10, 97, 98

N 10, 100

FRIENDLY

What it's about:

A warm and radiating orange is at the core of these color combinations. Practically ubiquitous in the arena of fast food, orange is cheerful and inviting. Bright enough to attract attention, but not so intense as to demand it, these soft oranges suggest the glowing light of an open flame, or the low rays of a desert sunset. Casual, happy, and easygoing, orange adds an upbeat attitude to each of these combinations. They are unassuming and highly approachable.

What it's good for:

Informal situations that require cheer and good humor
Fast food
Youth-oriented products
Casual hospitality

What to look out for:

Orange is also an international safety color. Avoid sending mixed signals when pairing it with high-contrast colors like black or green.

1 DESIGNER: ADAMSMORIOKA, INC. CLIENT: NICKELODEON

2 DESIGNER: HOWALT DESIGN STUDIO, INC CLIENT: NATURE'S HEALTHY ESSENTIALS

3 DESIGNER: SIMON & GOETZ DESIGN CLIENT: STEFAN TAPPERT

M 20, 23

M 17, 20

M 18, 24

M 19, 20, 22

M 18, 20, 23

M 17, 19, 20

SE 20, 52, 84

SE 17, 50, 81

SE 21, 53, 86

C 20, 68

C 23, 67

C 21, 66

C 18, 65

C 22, 70

C 21, 72

C 19, 67

SEE PROCESS COLOR CHART ON PAGE 152 FOR CMYK VALUES

A = ANALAGOUS C = COMPLEMENTARY CL = CLASH M = MONOCHROMATIC

N = NEUTRAL SE = SECONDARY S = SPLIT SC = SPLIT COMPLEMENTARY

A 4, 13, 20

A 7, 16, 20

A 6, 15, 18

A 12, 20, 27

A 12, 22, 26

A 14, 22, 26

A 15, 18, 20

A 20, 28, 36

SC 20, 62, 74

A 19, 29, 36

A 22, 32, 36

A 21, 27, 38

SC 20, 60, 76

SC 20, 63, 78

SC 19, 60, 79

SC 22, 58, 79

SC 21, 61, 76

S 22, 58, 76

S 20, 61, 68

S 21, 62, 78

C 20, 76

C 22, 79

C 21, 76

C 20, 60

N 17, 20

N 20, 98, 104

N 20, 101, 106

N 20, 97, 102

N 20, 98, 100

SOFT

What it's about:

Soft color schemes go out of their way to avoid drama and intensity. These palettes use lighter tints to convey a gentle sense of comfort. Light violets, muted pinks, and pale yellows combine to create a relaxing bouquet of unassuming hues. Calm and relaxing, these combinations offer a restful antidote in a world were messages constantly wrestle for attention. This palette is informed by a quiet sense of subtlety. Subdued and feminine, it soothes the mind and soul.

What it's good for:

Tourism and Travel
Fashion
Casual Dining

What to look out for:

Because of their light values, soft palettes may restrict the versatility of the identity in application. While they may be ideal in certain situations, be careful not to paint yourself into a corner.

1 **DESIGNER:** SAYLES GRAPHIC DESIGN, INC. **CLIENT:** MCATHUR COMPANY

2 **DESIGNER:** CHERMAYEFF & GEISMAR, INC. **CLIENT:** PINO ICE CREAM AND PASTRY SHOPS

3 **DESIGNER:** WAGES DESIGN **CLIENT:** LAKE LANIER ISLANDS

1 2 3

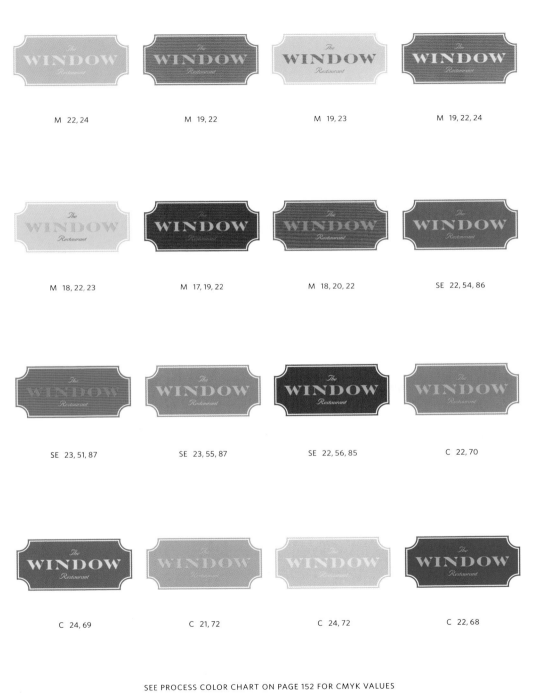

M 22, 24 M 19, 22 M 19, 23 M 19, 22, 24

M 18, 22, 23 M 17, 19, 22 M 18, 20, 22 SE 22, 54, 86

SE 23, 51, 87 SE 23, 55, 87 SE 22, 56, 85 C 22, 70

C 24, 69 C 21, 72 C 24, 72 C 22, 68

SEE PROCESS COLOR CHART ON PAGE 152 FOR CMYK VALUES

A = ANALAGOUS C = COMPLEMENTARY CL = CLASH M = MONOCHROMATIC

N = NEUTRAL S = SECONDARY S = SPLIT SC = SPLIT COMPLEMENTARY

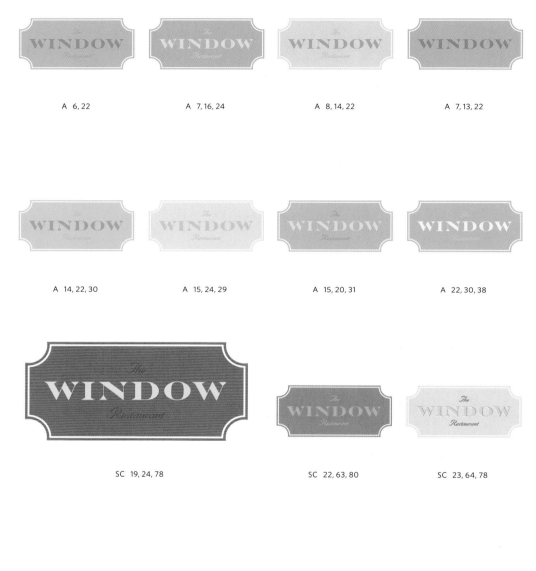

A 6, 22

A 7, 16, 24

A 8, 14, 22

A 7, 13, 22

A 14, 22, 30

A 15, 24, 29

A 15, 20, 31

A 22, 30, 38

SC 19, 24, 78

SC 22, 63, 80

SC 23, 64, 78

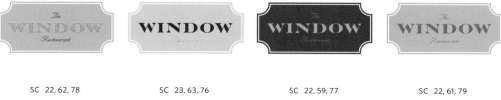

SC 22, 62, 78

SC 23, 63, 76

SC 22, 59, 77

SC 22, 61, 79

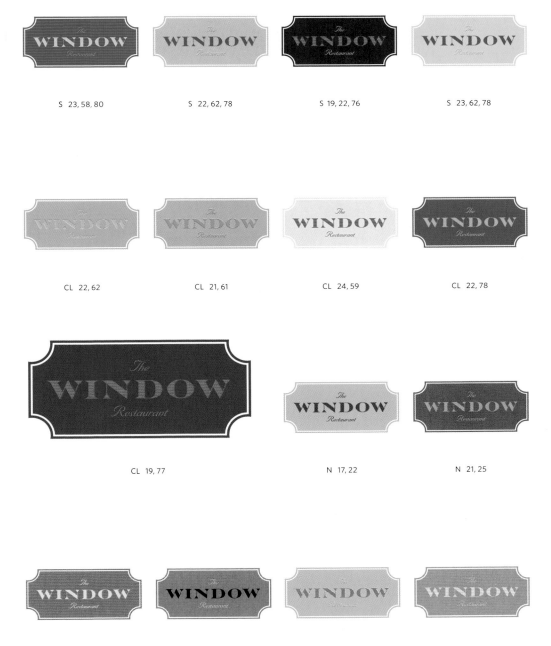

S 23, 58, 80

S 22, 62, 78

S 19, 22, 76

S 23, 62, 78

CL 22, 62

CL 21, 61

CL 24, 59

CL 22, 78

CL 19, 77

N 17, 22

N 21, 25

N 24, 26

N 22, 101, 105

N 22, 98, 101

N 22, 97, 100

WELCOMING

What it's about:

A welcoming palette is inviting and accessible. It has a lightness and brightness about it that suggests openness and honesty. These palettes are enlivened by warm yellows that radiate with sunny, fresh-baked optimism and cheer. Ranging in hue from buttery to deep gold, yellow promotes an air of approachable affability that immediately puts viewers at ease. In heraldry, yellow is the traditional color of loyalty.

What it's good for:

Food-related products

Products and services for younger children

Games and other applications where happiness and intellect are paramount

What to look out for:

Yellow and black are frequently used to advertise caution or warning. In its dullest hues, yellow can appear dingy, soiled or decayed. Yellow is also seen by some to suggest cowardice.

1 **DESIGNER:** PLANET PROPAGANDA **CLIENT:** SUNDOG

2 **DESIGNER:** CHASE DESIGN GROUP **CLIENT:** TOMMY STOILKOVICH

3 **DESIGNER:** CATO PURNELL PARTNERS **CLIENT:** BANK WEST

1

2

3

M 28, 30

M 26, 28

M 27, 31

M 26, 28, 29

M 25, 27, 28

M 27, 28, 31

T 28, 60, 92

T 26, 58, 90

T 30, 62, 94

T 27, 64, 95

C 28, 76

C 31, 74

C 26, 78

C 29, 77

C 31, 79

C 27, 75

SEE PROCESS COLOR CHART ON PAGE 152 FOR CMYK VALUES

A = ANALAGOUS C = COMPLEMENTARY CL = CLASH M = MONOCHROMATIC

N = NEUTRAL S = SPLIT SC = SPLIT COMPLEMENTARY T = TERTIARY

A 10, 20, 28

A 12, 22, 28

A 16, 22, 28

A 20, 28, 36

A 19, 29, 37

A 22, 29, 36

A 23, 26, 38

A 28, 36, 44

A 26, 38, 44

A 30, 39, 44

A 31, 35, 47

SC 28, 70, 84

SC 28, 68, 84

SC 28, 70, 86

SC 27, 69, 84

SC 29, 69, 83

SC 27, 68, 81

SC 30, 68, 87

S 29, 69, 82

S 28, 70, 86

S 28, 70, 87

CL 28, 68

CL 30, 65

N 25, 31

N 25, 28

N 26, 28

N 28, 101, 106

N 28, 98, 104

N 28, 97, 102

MOVING

What it's about:

At its brightest, yellow grabs attention like few other colors can. Its electric intensity energizes analogous, complementary, and even neutral palettes. Cheerful, lighthearted, and free-spirited, yellow moves both the body and soul. Recently, for example, the famed yellow jersey of the Tour de France has been parlayed into an awareness campaign for the Lance Armstrong Foundation. And if you want to move around New York, look no further than the nearest yellow cab — the color scheme of which stands out in a sea of cars to grab your attention.

What it's good for:

Products and services that promote action
Toys and games of young children
Performance products that value speed
Games and other applications where happiness and intellect are paramount

What to look out for:

Yellow disappears against a white background, so it almost always needs to be paired with a darker partner — be aware that black and yellow are used to signal caution.

1 **DESIGNER:** KELLUM MCCLAIN, INC. **CLIENT:** CROSSROADS COMMUNICATIONS
2 **DESIGNER:** MODERN DOG COMMUNICATIONS **CLIENT:** TARGET STORES
3 **DESIGNER:** GARDNER DESIGN **CLIENT:** ALIENS EXCAVATING

1

2

3

M 36, 39 M 35, 36 M 35, 40 M 34, 37, 39

M 36, 38, 40 M 34, 35, 36 M 34, 36, 40 P 4, 36, 66

P 2, 34, 66 P 6, 38, 70 P 5, 36, 65 C 36, 77

C 38, 82 C 35, 81 C 37, 87 C 36, 83

SEE PROCESS COLOR CHART ON PAGE 152 FOR CMYK VALUES

A = ANALAGOUS C = COMPLEMENTARY CL = CLASH M = MONOCHROMATIC

N = NEUTRAL P = PRIMARY S = SPLIT SC = SPLIT COMPLEMENTARY

A 20, 28, 36

A 22, 31, 36

A 23, 27, 35

A 28, 36, 44

A 30, 38, 44

A 31, 34, 46

A 36, 44, 52

A 39, 46, 52

A 36, 44, 52

SC 36, 75, 94

SC 36, 76, 84

SC 36, 78, 95

SC 35, 77, 92

SC 38, 77, 91

SC 39, 76, 90

S 38, 76, 91

S 34, 75, 90

CL 38, 73

CL 33, 75

CL 36, 92

CL 38, 94

N 36, 97, 102

N 33, 39

N 34, 36

N 36, 98, 100

N 36, 98, 104

Gauche

ELEGANT

What it's about:

Elegance is about understated simplicity. A definitive, refined statement can be made through the application of pale tints, pastels, and yellows. These colors convey distinction and luxury with grace and an unintimidating sense of ease. Muted colors of sage, rust, and soft blues can help contribute strength and presence without adding flashy ostentation. For marks that require an assured sense of confidence, these palettes are a good place to start.

What it's good for:

Sophisticated audiences
Mature fashion
Traditional events

What to look out for:

Generally, these colors are considered more feminine than masculine. Softer tones can also be mistaken for weakness; be sure to pair them with a strong accent for both grace and confidence.

1 **DESIGNER:** RANDY MOSHER DESIGN **CLIENT:** MDI, LLC
2 **DESIGNER:** CHASE DESIGN GROUP **CLIENT:** WARNER BROS. RECORD
3 **DESIGNER:** JAMES LIENHART DESIGN **CLIENT:** BEATRICE

Beatrice

1 2 3

M 38, 34

M 35, 39

M 35, 40

M 37, 34, 40

M 34, 38, 39

M 35, 38, 39

P 7, 39, 71

P 6, 38, 70

C 39, 87

C 40, 86

C 40, 83

C 38, 86

C 40, 88

C 39, 85

Gauche

C 37, 85

Gauche

A 23, 31, 39

SEE PROCESS COLOR CHART ON PAGE 152 FOR CMYK VALUES

A = ANALAGOUS C = COMPLEMENTARY CL = CLASH M = MONOCHROMATIC

N = NEUTRAL P = PRIMARY S = SPLIT SC = SPLIT COMPLEMENTARY

A 22, 32, 39

A 24, 30, 38

A 31, 39, 46

A 32, 40, 47

A 30, 40, 47

A 38, 48, 54

A 40, 48, 56

A 39, 46, 55

A 40, 46, 55

SC 39, 75, 93

SC 37, 80, 94

SC 39, 78, 93

SC 38, 80, 94

S 40, 77, 96

S 38, 78, 93

S 39, 80, 96

CL 39, 79

CL 40, 78

CL 37, 94

CL 39, 95

N 26, 40

N 17, 38

N 25, 39

N 39, 100, 101

N 39, 98, 99

N 39, 97, 101

TRENDY

What it's about:

Paul Simon wrote that "every generation throws a hero up the pop charts"; color is no exception. Every season seems to usher in a new must-use color. These trends tend to be funky, vibrant, and attractive. Although not traditionally long-lasting in appeal, most will return for an encore. Lately, bright and energetic greens have reasserted themselves, conveying myriad qualities that are perfectly subjective to popular opinion. The fun lies in the novelty and playfulness of the colors, created through the risk that accompanies calling attention to oneself.

What it's good for:

Music and fashion
Television graphics
Products and services aimed at teen markets

What to look out for:

It's easy to fall in love with many of these hues, but every season brings a new trend, and what's hot today may look dated tomorrow.

1 DESIGNER: CATO PURNELL PARTNERS CLIENT: MUSEUMS WITH VISIONS
2 DESIGNER: CRE8 COMMUNICATIONS, INC. CLIENT: WESTERN RECREATIONAL VEHICLES, INC.
3 DESIGNER: CATO PURNELL PARTNERS CLIENT: WESTAR ENERGY

1 2 3

M 44, 47

M 42, 44

M 42, 44, 46

M 41, 44, 47

M 42, 44, 48

T 12, 44, 76

T 14, 46, 78

T 10, 43, 74

T 9, 44, 79

C 44, 92

C 45, 89

C 47, 93

C 42, 91

C 45, 96

C 41, 90

C 47, 89

SEE PROCESS COLOR CHART ON PAGE 152 FOR CMYK VALUES

A = ANALAGOUS C = COMPLEMENTARY CL = CLASH M = MONOCHROMATIC

N = NEUTRAL S = SPLIT SC = SPLIT COMPLEMENTARY T = TERTIARY

A 28, 39, 44

A 25, 39, 44

A 36, 44, 52

A 39, 47, 52

A 25, 37, 44

A 40, 43, 54

A 44, 52, 60

A 41, 53, 60

A 45, 55, 60

A 47, 50, 60

SC 4, 44, 84

SC 8, 44, 82

SC 7, 44, 86

SC 4, 46, 87 SC 2, 45, 86 SC 1, 42, 84 SC 6, 48, 84

S 1, 45, 84 S 5, 44, 86 S 8, 44, 87 CL 4, 44

CL 3, 47 CL 44, 84 CL 46, 82 N 41, 48

N 41, 44 N 44, 98, 100 N 44, 98, 104 N 41, 102, 104

FRESH

What it's about:

Freshness in a color palette creates a spring-like, bright and cheerful mood. Apple greens, sunshine yellows, and crisp blues mimic fruit, vegetables, sea and sky, and suggest an abundance of life and natural energy. These colors recall the vibrant hues of our living environment in an open, pure, and sometimes childlike manner. Fresh palettes are formed of a renewing and empowering combination of strong, solid hues mixed with soft, natural complements.

What it's good for:

Culinary ventures
Spring fashion
Nurseries and landscaping
Day care centers and other child services

What to look out for:

Freshness can convey a feeling of immaturity and childlike intention. Too many bright hues can make an environment look busy, scattered, and unfocused.

1 **DESIGNER:** CHERMAYEFF AND GEISNER, INC. **CLIENT:** TULIP FILMS
2 **DESIGNER:** SIBLEY PETEET DESIGN **CLIENT:** CHILI'S
3 **DESIGNER:** SIBLEY PETEET DESIGN **CLIENT:** TIM MCCLURE

1 2 3

M 52, 55

M 49, 56

M 50, 42, 54

M 51, 52, 55

M 49, 51, 52

M 52, 53, 56

SE 20, 52, 84

SE 18, 50, 82

SE 21, 53, 85

SE 22, 49, 87

C 2, 54

C 3, 56

C 5, 55

A 36, 44, 52

A 38, 45, 52

A 36, 45, 52

SEE PROCESS COLOR CHART ON PAGE 152 FOR CMYK VALUES

A = ANALAGOUS C = COMPLEMENTARY CL = CLASH M = MONOCHROMATIC

N = NEUTRAL S = SPLIT SC = SPLIT COMPLEMENTARY SE = SECONDARY

A 44, 52, 60

A 44, 54, 60

A 39, 46, 51

A 46, 52, 60

A 46, 50, 62

A 52, 60, 68

A 51, 62, 68

A 54, 62, 68

A 55, 58, 70

SC 14, 52, 92

SC 7, 52, 95

SC 12, 50, 94

SC 11, 55, 95

SC 14, 54, 92

SC 10, 55, 92

SC 6, 52, 94

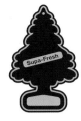

CL 54, 90

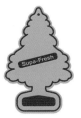

CL 11, 53

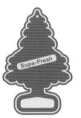

N 49, 56

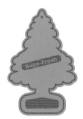

N 49, 52

N 50, 53

N 49, 53

N 52, 98, 100

N 52, 101, 102

N 52, 98, 104

N 52, 97, 102

AgPreference

SEEING GREEN

"I was always told that green was a bad color selection for a bank," says veteran designer Bill Gardner. "Consumers correlate the color green with money, and this can be a crass association in the consumer's mind." So what were the circumstances that led him to make this seemingly aggressive color choice for AgPreference Bank? A little context puts it in perspective:

AgPreference Bank is part of the nationwide Farm Credit network. The system has a universal symbol called the "Green BioStar" that all of the banks use to indicate their affiliation — so hundreds of district banks with hundreds of different names all use exactly the same logo to market themselves. AgPreference wanted a unique identity, while maintaining the equity of their relationship with the Farm Credit network.

To help maintain this equity, the logos Gardner proposed were primarily based on abstractions of the familiar star shape. Moreover, they all employed

a dark green that was an exact PMS match to the Green BioStar. Practically speaking, this also makes the identity affordable to reproduce, since both marks are so frequently used together. Gardner did introduce a second, lighter green to enliven the inherited color palette. Together, Gardner says that the colors communicate a sense of "freshness, growth and security that the bank's unique customer base understands instantly.

"Every single customer for this bank must rely on organic growth to make an income," he explains, "So we jumped the traditional association of 'green means money' because for this very specific customer base, green means growth."

DESIGNER: GARDNER DESIGN **CLIENT:** AGPREFERENCE BANK

ALL NATURAL

MINE: Blue and green are often associated with healthcare — why do you think that is, and how heavily did it influence your color decisions?

WOW Branding: When we think health, we often think of natural sources, like water, Earth, and sky. Clean blues and fresh greens come to mind. We opted for an earthier green for Health First's primary color, due to the nature of their business — vitamins and health supplements. The color seemed to work perfectly with the stylized leaf logo. The next challenge was trying to get across the notion of energy and vitality. We did this through the colors in their family of products.

MINE: What other colors did you consider for this mark?

WOW: Brighter oranges and reds were considered for their vitality, but we decided on an earthy green to represent the corporate brand instead. This green is used in all of their marketing collateral, along with its supporting complement, orange — adding energy

and contrast to the earthier green. We then chose cleaner, crisper colors to differentiate each product category. Each conveys health, trust, and vitality.

MINE: This particular shade of green is fairly dark and earthy — why did you favor this shade over something brighter?

WOW: We wanted to communicate two key points: health and energy. We used the earthy green for the corporate brand identity, and brighter, more energetic colors for the product line. Without the green, the brand color story would have been too bright and cheerful — it needed the one earth tone to ground it and tie everything together.

DESIGNER: WOW BRANDING CLIENT: HEALTH FIRST

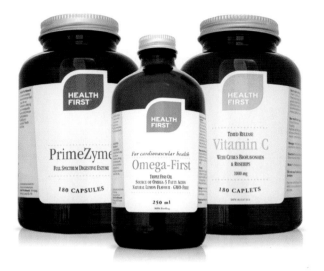

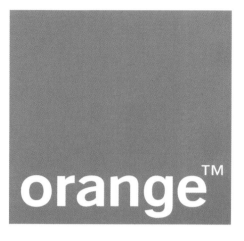

ORANGE IDEA

Jonathan Staines is the Brand Identity and Development Manager at Orange, a UK-based, international cellular company with a bold, fresh, brand promise. His role is to protect, promote, and develop the Orange brand, while ensuring that it represents and communicates the company's message accurately. It's a formidable task, given the breadth of the company's activities and ambitions — including video and music services and leading-edge mobile entertainment offerings such as Orange TV. What makes his job easier is the company's apparent commitment to simplicity and clarity.

The name, Orange, is about as simple as it gets. What does a logo for a company called "Orange" look like? Why, it's orange, of course. "The color and the ideas behind it are central to the brand ethos," explains Jonathan, who says that the key idea behind the brand is "optimism." In research, orange (the color, not the fruit) was consistently connected with positive associations of warmth, humanity, and wellbeing. As a name, it also had the added benefit of not focusing on specific technology — i.e. names featuring *tel, net, fone, com*, etc. The name, therefore, becomes about the color and the feelings one associates with it. To

help solidify this association (and disassociate the brand with the citrus of the same name), the logo is rendered in a simple square, quashing any mental image one might have of the spherical fruit.

This straightforward combination of color and shape is powerfully iconic, slyly witty, and surprisingly intellectual. Reminiscent of Piet Zwart's famous "black square" personal logo, it communicates with a directness and honesty that is both reassuring and uplifting. Supported by a simple palette of black, white, and the occasional gray, the Orange logo also has a stylish quality that Jonathan insists is not about fashion. "Orange represents optimism, and that is a universal idea that transcends fashion and trends. Although colors go in and out of fashion, they also endure because they are natural phenomena."

Time will tell if orange will transcend itself the way brown has for UPS or blue has for IBM, but so far the company has done a remarkable job of leveraging color to capture and own an idea.

DESIGNER: JWT CLIENT: ORANGE

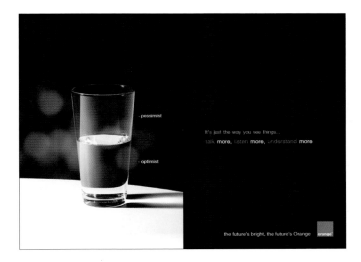

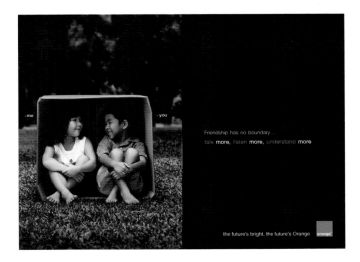

Above:
2002 Thai ads from Orange's optimistically-positoned
"Talk More, Listen More, Understand More" campaign.
Note the deliberately restrained use of color.

TRUE BLUE

For decades, it seems, blue has been the go-to color for conservative corporate identities. Ford, GM, Chase, IBM, American Express, Gap, TimeWarner, AOL, AT&T, General Mills, Dell, and Wal-Mart are just a few of the most familiar examples of those who embrace blue as their hue of choice. IBM has been nicknamed "Big Blue." American Express offers a card called "Blue." The Gap even briefly released a fragrance called "655" (their official corporate PMS color). In fact, of *Fortune*'s 2005 list of the 100 largest companies in the United States, 51 of them use blue for their corporate logo, and by some estimates, approximately 70 percent of all U.S. companies have adopted blue as their corporate color. What is it about this color that appeals to so many of America's top companies?

Blue is by most accounts the most universally appealing color. It has a positive association with clear skies and the open sea that lend it a calming, non-confrontational character. While tests show that colors like red actually increase blood pressure, blue has the opposite physiological effect. Jet Blue (another "blue" company) is embracing this phenomenon by adding a channel to their in-flight DVD service that features a continuous video of clouds, set against a series of calming blue backgrounds. The same technology is already in use at children's hospitals to help soothe patients.

In corporate identity, blue represents a similar opportunity. It is a safe, conservative choice, liked equally by both men and women. Blue presents an image of stability, dignity, and confidence, and suggests the strength of institutional power. Its association with these venerable qualities have helped establish it as a non-controversial choice for corporate identity — especially in larger corporate structures where committee-based decision-making guides corporate branding decisions. As the political structures of major corporations become more complex through mergers and acquisitions, it's likely that the popularity of this color choice will increase. Companies like Chase and TimeWarner for

example — both of which have undergone numerous mergers over the years — have seen the color component of their identities endure. The reassurance of a blue-ribbon, blueblood pedigree helps provide a much needed thread of continuity and stability. Newer companies, on the other hand, can turn to blue as a means of instantly creating a feeling of establishment, safety, and trustworthiness.

OPPOSITE:

DESIGNER: CHERMAYEFF & GEISMAR, INC.
CLIENT: THE CHASE MANHATTAN BANK

DESIGNER: CHERMAYEFF & GEISMAR, INC.
CLIENT: PAN AMERICAN AIRWAYS

ABOVE: (CLOCKWISE FROM TOP LEFT)

DESIGNER: HORNALL ANDERSON DESIGN WORKS
CLIENT: NORDSTROMS

DESIGNER: WEBSTER DESIGN ASSOCIATES INC.
CLIENT: FIRST NATIONAL BROKERAGE

DESIGNER: INTERBRAND
CLIENT: PRICEWATERHOUSECOOPERS

DESIGNER:ALTERPOP
CLIENT: CAMBRIA ENVIRONMENTAL TECHNOLOGIES

DESIGNER: HOWALT DESIGN STUDIO, INC.
CLIENT: NATIONAL FOOTBALL LEAGUE

TRADITIONAL

What it's about:

For stability and comfort, forest green, navy blue, and gold underpin the traditional palette. These colors can be bold and inviting, but always remain connected to their distinguished, prestigious pedigrees. Think of a classic Jaguar in British racing green, or the quintessential blue blazer. These are not colors that suggest adventure or risk, preferring to rely on the tried and true. They are stable, safe, and unwavering. Generally associated with the surroundings of elite society, these colors start strong and are complemented with grace and nobility.

What it's good for:

Private clubs and societies
Private schools
Law firms
Investment houses

What to look out for:

Tradition can be a mark of distinction, but also can be seen as dated. To some, these colors suggest a form of elitism and exclusivity that can be offputting.

1 **DESIGNER:** DOGSTAR **CLIENT:** BLACK WARRIOR CAHABA RIVERS LAND TRUST

2 **DESIGNER:** GARDNER DESIGN **CLIENT:** CRC CONSTRUCTION

3 **DESIGNER:** CHERMAYEFF & GEISMAR, INC. **CLIENT:** BANCO DE ITALIA, BUENOS AIRES

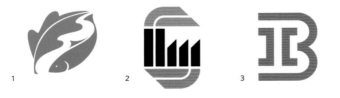

1 2 3

M 49, 56

M 49, 54

M 49, 51, 54

M 49, 53, 55

M 49, 51, 53

M 49, 54, 56

SE 17, 49, 81

SE 18, 50, 86

SE 23, 49, 84

C 16, 49

C 1, 55

C 5, 49

C 7, 51

A 33, 41, 49

A 38, 43, 50

A 34, 42, 49

SEE PROCESS COLOR CHART ON PAGE 152 FOR CMYK VALUES

A = ANALAGOUS C = COMPLEMENTARY CL = CLASH M = MONOCHROMATIC

N = NEUTRAL SE = SECONDARY S = SPLIT SC = SPLIT COMPLEMENTARY

A 38, 43, 50 A 48, 50, 63 A 43, 49, 59 A 47, 49, 58

A 49, 59, 66 A 49, 61, 71 SC 10, 50, 90 SC 13, 49, 91

SC 14, 50, 96 SC 16, 49, 90

SC 15, 50, 89 S 9, 50, 89 SC 14, 51, 90

S 13, 49, 90

S 15, 50, 91

S 16, 49, 94

CL 49, 89

CL 49, 95

CL 14, 49

CL 49, 95

CL 11, 50

N 26, 51

N 16, 49

N 17, 49

N 37, 98, 103

N 49, 97, 99

N 49, 98, 100

REFRESHING

What it's about:

The cerulean hues of cool blue and aqua are the hallmarks of a refreshing color scheme. These colors serve a dual purpose — simultaneously soothing and invigorating the senses. In monochromatic, analogous combinations, this blue soothes and relaxes, while in other combinations it becomes a much more energized hue. When paired with soft yellow-orange or coral, especially, it will enliven any logo.

What it's good for:

Sports drinks
Hygiene products
Travel and Leisure

What to look out for:

Blue is considered the least appetizing of all the colors. While it may be suitable for candies and energy drinks, avoid using blues to represent food products.

1 **DESIGNER:** CHERMAYEFF & GEISMAR, INC. **CLIENT:** CENTRO DE CONVENCIONES DE CARTAGENA

2 **DESIGNER:** CHERMAYEFF & GEISMAR, INC. **CLIENT:** TELEMUNDO

3 **DESIGNER:** SPATCHURST **CLIENT:** CAPITOL THEATRE

1

2

3

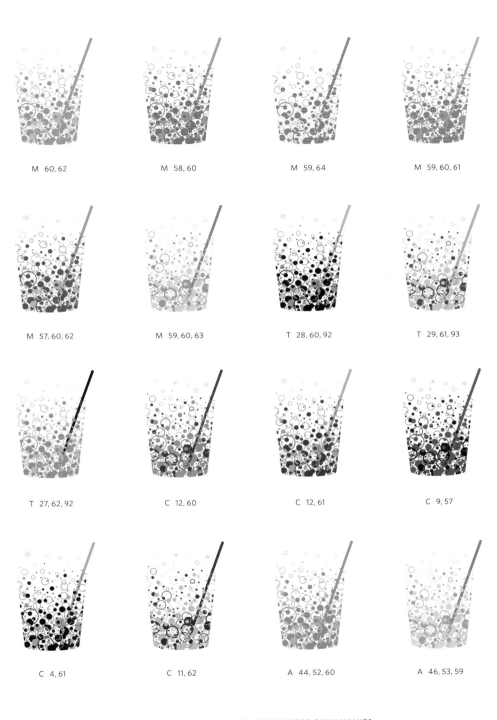

M 60, 62　　　　M 58, 60　　　　M 59, 64　　　　M 59, 60, 61

M 57, 60, 62　　　M 59, 60, 63　　　T 28, 60, 92　　　T 29, 61, 93

T 27, 62, 92　　　C 12, 60　　　　C 12, 61　　　　C 9, 57

C 4, 61　　　　C 11, 62　　　　A 44, 52, 60　　　A 46, 53, 59

SEE PROCESS COLOR CHART ON PAGE 152 FOR CMYK VALUES

A = ANALAGOUS　　C = COMPLEMENTARY　　CL = CLASH　　M = MONOCHROMATIC

N = NEUTRAL　　S = SPLIT　　SC = SPLIT COMPLEMENTARY　　T = TERTIARY

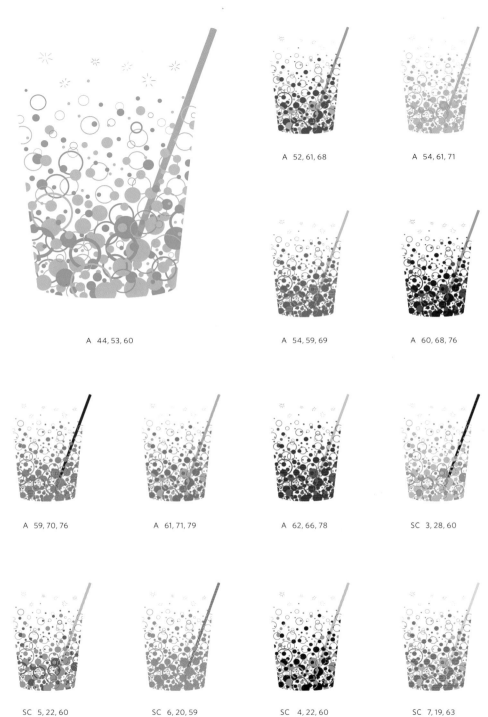

A 44, 53, 60

A 52, 61, 68

A 54, 61, 71

A 54, 59, 69

A 60, 68, 76

A 59, 70, 76

A 61, 71, 79

A 62, 66, 78

SC 3, 28, 60

SC 5, 22, 60

SC 6, 20, 59

SC 4, 22, 60

SC 7, 19, 63

SC 6, 23, 62

S 5, 22, 60

S 6, 19, 60

CL 4, 60

CL 6, 64

CL 7, 59

CL 20, 60

S 20, 52, 61

CL 18, 62

N 9, 60

N 60, 97, 102

N 60, 98, 104

N 60, 101, 106

TROPICAL

What it's about:

The carefree color of turquoise is the central theme to a tropical palette. Inspired by the waters around the equator, light tints of blues and greens offer the viewer a virtual escape. Splashes of coral, orange, and violet mimic the pleasing hues of tropical sunsets, and infuse these palettes with an inviting, peaceful tone. Tropical palettes are both refreshing and inspiring, and shouldn't be relegated simply to tropical-themed applications.

What it's good for:

Travel and Leisure
Youth-oriented products
Fitness and wellness centers

What to look out for:

Many ethnicities and cultures are identified with the colors of the tropics. These stereotypes sometimes prevail over the intended feeling.

1 **DESIGNER:** CATO PURNELL PARTNERS **CLIENT:** SYDNEY AIRPORT

2 **DESIGNER:** EISENBERG AND ASSOCIATES **CLIENT:** TUCSON ZOOLOGICAL SOCIETY

3 **DESIGNER:** JOHN EVANS DESIGN **CLIENT:** PURPLE GIRAFFE T-SHIRT CO.

1 2 3

M 62, 64 M 59, 62 M 59, 63 M 59, 63, 64

M 58, 62, 63 M 62, 63, 64 M 58, 60, 62 T 30, 62, 94

T 29, 64, 93 T 31, 63, 95 C 14, 62 C 13, 63

C 16, 63 C 13, 61 C 16, 60 C 15, 63

SEE PROCESS COLOR CHART ON PAGE 152 FOR CMYK VALUES

A = ANALAGOUS C = COMPLEMENTARY CL = CLASH M = MONOCHROMATIC

N = NEUTRAL S = SPLIT SC = SPLIT COMPLEMENTARY T = TERTIARY

C 12, 61 C 11, 64 A 46, 54, 62 A 45, 55, 62

A 48, 55, 64 A 47, 53, 62 A 53, 63, 69

A 56, 63, 72 A 64, 72, 80 A 63, 69, 79 A 62, 70, 78

SC 6, 22, 62 SC 5, 23, 62 SC 7, 23, 62 SC 6, 21, 62

SC 6, 22, 64

S 5, 22, 63

S 8, 23, 62

S 6, 20, 64

CL 6, 62

CL 5, 64

S 29, 64, 93

CL 24, 63

CL 21, 61

N 17, 62

N 26, 63

N 60, 98, 100

N 61, 97, 102

N 63, 101, 105

N 62, 98, 104

CLASSIC

What it's about:

The classic color is one that never goes out of style. A rich royal blue depicts an entity that is responsible, trustworthy, and valuable. Royal blue lends an air of respectability and authority, connecting to a sense of tradition and leadership. Ideally, a classic palette would stay within the chosen hue's analogous range, expressing a sense of tradition and stability, wisdom, faith and (generally) conservative values.

What it's good for:

Faith-based organizations (Western)
Charities
Honor societies
Social events

What to look out for:

Classic can be easily misinterpreted as stodgy or boring.

1	DESIGNER: CHERMAYEFF & GEISMAR, INC.	CLIENT: HARPERCOLLINS
2	DESIGNER: MIRES	CLIENT: LAS VEGAS CHAMBER OF COMMERCE
3	DESIGNER: CHERMAYEFF & GEISMAR, INC.	CLIENT: AMERICAN REVOLUTION BICENTENNIAL COMMISSION

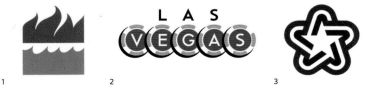

1 2 3

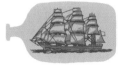 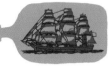 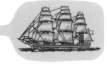

M 68, 70 M 65, 68 M 66, 71 M 65, 67, 69

P 4, 36, 68 P 2, 34, 66 P 5, 37, 69 P 5, 35, 68

C 20, 68 C 17, 69 C 19, 71 C 21, 69

C 21, 69 C 22, 70 C 17, 66 K 19, 68

SEE PROCESS COLOR CHART ON PAGE 152 FOR CMYK VALUES

A = ANALAGOUS C = COMPLEMENTARY CL = CLASH M = MONOCHROMATIC

N = NEUTRAL P = PRIMARY S = SPLIT SC = SPLIT COMPLEMENTARY

A 52, 60, 68 A 54, 62, 68 A 53, 62, 66 A 60, 68, 76

A 62, 70, 76 A 61, 67, 78 A 69, 80, 84 A 68, 80, 82

A 71, 78, 84 A 72, 75, 87 SC 12, 28, 68 SC 10, 29, 68

SC 14, 29, 68 SC 15, 28, 67 SC 11, 29, 69

SC 14, 28, 70

S 10, 28, 68

S 13, 29, 68

S 14, 30, 68

CL 12, 68

CL 15, 71

CL 13, 69

CL 11, 67

CL 26, 68

CL 25, 65

N 19, 67

N 17, 68

N 68, 101, 106

N 68, 98, 104

DEPENDABLE

What it's about:

In fashion, the most dependable fabric is arguably denim, traditionally offered in navy blue, the work-horse of colors. Navy blue has instant integrity — it is strong and assured, presenting a confident, yet perfectly approachable demeanor. It is the uniform of the working man, the ship captain, and the police officer. It conveys a sense of knowledge, tradition and steadfast strength.

What it's good for:

Architectural firms
Governmental entities
Conservative corporate clients

What to look out for:

Blue is sometimes considered a sad or melancholy color. It's also considered a masculine color, so be sure you're not excluding your female audience.

1 **DESIGNER:** DOTZERO DESIGN **CLIENT:** RICH HENDERSON
2 **DESIGNER:** CHERMAYEFF & GEISMAR, INC. **CLIENT:** PUBLIC BROADCASTING SERVICE
3 **DESIGNER:** KEN SHAFER DESIGN **CLIENT:** NATIONAL FOOTBALL LEAGUE

1

2

3

M 65, 67 M 65, 69 M 66, 71 M 65, 67, 70

M 65, 68, 70 M 66, 69, 72 M 65, 67, 72 P 3, 35, 66

P 2, 34, 67 P 1, 33, 65 C 17, 65 C 19, 67

C 21, 65 C 22, 66 C 23, 67 C 24, 65

SEE PROCESS COLOR CHART ON PAGE 152 FOR CMYK VALUES

A = ANALAGOUS C = COMPLEMENTARY CL = CLASH M = MONOCHROMATIC

N = NEUTRAL P = PRIMARY S = SPLIT SC = SPLIT COMPLEMENTARY

A 61, 67, 74

A 50, 59, 65

A 51, 61, 66

A 50, 62, 67

A 63, 65, 78

A 57, 70, 76

A 65, 78, 83

A 65, 79, 84

SC 15, 31, 66

SC 9, 27, 66

SC 10, 26, 65

SC 14, 25, 65

SC 9, 26, 65

SC 11, 26, 65

SC 14, 32, 65

S 10, 26, 65

S 15, 26, 65

S 9, 31, 66

S 14, 31, 65

CL 9, 63

CL 15, 65

CL 11, 66

CL 27, 66

CL 30, 67

CL 32, 65

N 26, 65

N 18, 65

N 65, 97, 102

N 65, 98, 104

CALM

What it's about:

When emotionally stressed, light blue is sure to calm your nerves. The soothing combination of subtle grays with tints of blue is soft, slow, and relaxing. When blue is combined with its dusty orange complement, the duo recalls — like a fading postcard from a seaside resort — clear skies, gentle breezes, and sandy beaches.

What it's good for:

Hospitals
Waiting rooms
Areas of high stress

What to look out for:

Light blue can be too subtle or lack the authority necessary to drive the point home. A more saturated blue references baby boys and could get in the way of your intended message.

1 **DESIGNER:** GARDNER DESIGN **CLIENT:** HOME OIL COMPANY
2 **DESIGNER:** DOTZERO DESIGN **CLIENT:** LEARNING.COM
3 **DESIGNER:** DOGSTAR **CLIENT:** CATHARINE FISHEL

1 2 3

M 70, 72

M 65, 70

M 67, 70, 72

M 65, 70, 71

M 65, 67, 72

M 68, 71, 72

P 7, 39, 69

P 8, 40, 71

P 5, 36, 71

C 22, 70

C 24, 72

C 21, 70

C 19, 71

C 18, 69

C 21, 69

C 22, 72

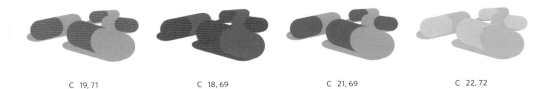

SEE PROCESS COLOR CHART ON PAGE 152 FOR CMYK VALUES

A = ANALAGOUS C = COMPLEMENTARY CL = CLASH M = MONOCHROMATIC

N = NEUTRAL P = PRIMARY S = SPLIT SC = SPLIT COMPLEMENTARY

A 53, 63, 71

A 57, 63, 70

A 55, 61, 72

A 64, 72, 80

A 64, 71, 78

A 62, 70, 78

A 61, 70, 79

A 70, 78, 86

A 69, 79, 88

S 10, 28, 69

SC 14, 30, 70

SC 15, 31, 71

SC 16, 32, 72

SC 12, 29, 70

SC 14, 30, 70

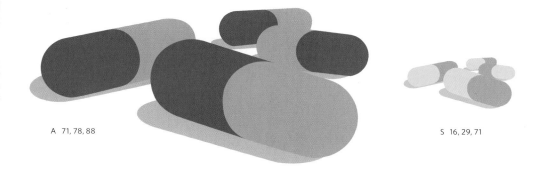

A 71, 78, 88

S 16, 29, 71

S 11, 31, 72

CL 30, 70

CL 32, 72

CL 27, 70

CL 14, 70

CL 9, 70

N 17, 70

N 26, 72

N 72, 97, 100

N 71, 97, 99

N 67, 97, 100

REGAL

What it's about:

The combination of blue and red creates a deep violet hue — once a pigment so scarce, it was only available to royalty. For this reason, it has come to be associated with wealth, majesty, and authority. A regal color scheme is appropriate for logos that make a historical reference, are based on heraldry or tradition, and those which intend to project a sense of leadership and excellence.

What it's good for:

Products and companies that reference royalty
High-end consumer goods
Fine clothiers and tailors

What to look out for:

Purple is also related to death, so use it carefully.

1 **DESIGNER:** RICHARDS BROCK MILLER MITCHELL & ASSOCIATES **CLIENT:** DALLAS SYMPHONY ORCHESTRA
2 **DESIGNER:** PREJEAN LOBLUE **CLIENT:** THE KING RANCH VINEYARD PARTNERSHIP
3 **DESIGNER:** GARDNER DESIGN **CLIENT:** KANSAS HEALTH FOUNDATION

1 2 3

M 76, 78 M 73, 76 M 75, 79 M 74, 76, 77

M 73, 77, 79 M 73, 76, 80 T 12, 44, 76 T 12, 45, 78

C 28, 76 C 27, 78 C 26, 80 C 25, 75

C 30, 78 C 27, 74 A 60, 68, 76 A 60, 69, 76

SEE PROCESS COLOR CHART ON PAGE 152 FOR CMYK VALUES

A = ANALAGOUS C = COMPLEMENTARY CL = CLASH M = MONOCHROMATIC

N = NEUTRAL S = SPLIT SC = SPLIT COMPLEMENTARY T = TERTIARY

A 61, 69, 76

A 62, 70, 75

A 68, 78, 84

A 70, 79, 84

A 72, 74, 86

A 80, 82, 95

SC 22, 37, 76

SC 20, 39, 74

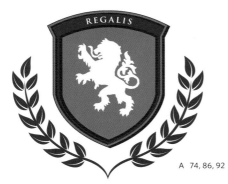

A 74, 86, 92

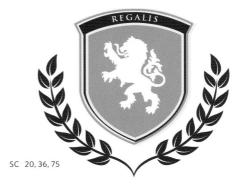

SC 20, 36, 75

SC 19, 39, 78

SC 21, 36, 85

S 19, 36, 78

S 22, 38, 76

S 19, 34, 75 S 21, 38, 76 C 36, 76 C 38, 78

C 34, 73 C 20, 76 C 18, 78 N 25, 73

 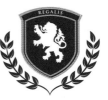

C 17, 87 N 26, 76 N 27, 76

 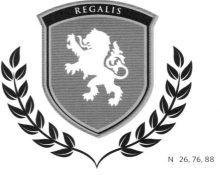

N 76, 98, 100 N 76, 97, 99 N 26, 76, 88

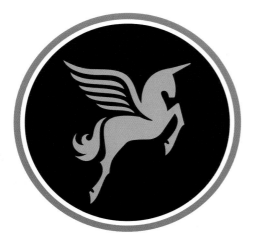

MAGICAL

What it's about:

With an ace up its sleeve and some quick slight of hand, violet is considered the most magical color of all. Its combination with yellow is extremely powerful, captivating, and fun. The mystery behind this color is locked in its dark past. Perhaps the close association that violet has with death plays a role in its mysterious ways.

What it's good for:

Connoting mystery and mysticism
Theater and performing arts

What to look out for:

Darker shades of violet may be mistakenly associated with royalty and opulence. Purple is also seen as unpredictable, and in some cultures signifies death — use it carefully.

1 **DESIGNER:** KIKU OBATA AND COMPANY **CLIENT:** THE PAGEANT

2 **DESIGNER:** CHASE DESIGN GROUP **CLIENT:** SHOWTIME NETWORKS

3 **DESIGNER:** ASSOCIATED ADVERTISING AGENCY **CLIENT:** WICHITA ANESTHESIOLOGY CHARTERED

1

2

3

M 84 M 84, 86 M 81, 84, 88 M 83, 87

M 81, 84, 87 M 84, 86, 87 M 82, 84, 88 SE 20, 52, 84

SE 18, 49, 83 SE 20, 55, 82 C 36, 84 C 34, 82

C 38, 88 C 38, 86 C 35, 83 A 70, 76, 84

SEE PROCESS COLOR CHART ON PAGE 152 FOR CMYK VALUES

A = ANALAGOUS C = COMPLEMENTARY CL = CLASH M = MONOCHROMATIC

N = NEUTRAL S = SPLIT SC = SPLIT COMPLEMENTARY SE = SECONDARY

A 68, 79, 84

A 71, 78, 83

A 76, 84, 92

A 78, 81, 93

A 73, 87, 92

A 4, 84, 92

A 5, 85, 91

A 4, 85, 94

A 4, 83, 94

SC 28, 44, 84

SC 30, 44, 83

SC 28, 46, 85

SC 31, 42, 86

S 28, 42, 86

S 29, 46, 84

SC 28, 44, 81

S 27, 42, 82

CL 44, 84

CL 41, 81

CL 28, 84

CL 26, 86

CL 25, 87

N 33, 81

N 35, 84

N 84, 98, 101

N 84, 97, 98

NOSTALGIC

What it's about:

With the power of memory comes the emotion of nostalgia. Rich colors quickly fading away to pale hues form the conceptual basis of this color palette. Like the "purple mountain's majesty," sung in *America the Beautiful*, lavender often represents nostalgia. The Victorian era is closely associated with lavender as well, due to its dreamy, romantic qualities.

What it's good for:

Referencing the past

Romantic products and experiences

Inns and other hospitality-based enterprises

What to look out for:

When referencing eras or movements from the past, be very specific with your color choices to avoid mixing time periods and confusing your message.

1 **DESIGNER:** SABINGRAFIK, INC. **CLIENT:** ALLIANCE FEDERAL CREDIT UNION

2 **DESIGNER:** SABINGRAFIK, INC. **CLIENT:** DESIGN SAFARI

3 **DESIGNER:** MODERN DOG COMMUNICATIONS **CLIENT:** AMERICAN DESIGN AND MANUFACTURING

1 2 3

M 86, 88

M 84, 86

M 83, 88

M 83, 86, 88

M 83, 85, 87

M 81, 86, 88

SE 22, 54, 86

SE 19, 51, 87

SE 22, 50, 86

C 38, 86

C 39, 87

C 40, 88

C 37, 85

C 40, 83

C 35, 86

C 35, 88

SEE PROCESS COLOR CHART ON PAGE 152 FOR CMYK VALUES

A = ANALAGOUS C = COMPLEMENTARY CL = CLASH M = MONOCHROMATIC

N = NEUTRAL S = SPLIT SC = SPLIT COMPLEMENTARY SE = SECONDARY

A 70, 78, 86

A 72, 79, 88

A 71, 77, 83

A 78, 86, 94

A 77, 86, 95

A 79, 88, 94

A 80, 85, 92

A 8, 85, 95

A 6, 86, 94

SC 31, 42, 86

SC 27, 47, 86

SC 32, 42, 85

SC 31, 46, 87

S 30, 45, 82

S 32, 47, 86

CL 46, 86

CL 48, 86

CL 32, 87

CL 29, 86

CL 47, 85

N 97, 86, 101

N 25, 85

N 18, 86

N 87, 97, 100

N 88, 98, 102

N 85, 96, 103

me&b.
M A T E R N I T Y

PRETTY IN PINK

Me&b is a line of fashionable, modern, maternity clothes, developed for professional working mothers. In developing the logo — an elegantly simple type-only solution — Chicago-based Liska + Associates relied on color to add a layer of personality to its thinly articulated form.

It was important to the client (and therefore the designer) to communicate a sense of professionalism and confidence, while also acknowledging the uniquely feminine aspect of maternity. As Liska + Associates put it, "Pregnancy is a very 'female' time in a woman's life." Even though designers are trained to push beyond the cliché, sometimes the obvious choice is the best one. In this case, using pink to connect to a female audience was clearly the appropriate choice. It is a soft, gentle color that ideally represents the relationship between mother and child. However, the clothing line needed to break away

from traditional associations of maternity clothing as dowdy, dated, and unfashionable, typified by the use of light, pastel colors. Instead, a sense of professionalism, confidence, and style had to be infused into the mark, and for that designers borrowed from a contrasting palette. Although they explored many color companions to the pink, Liska ultimately settled on a rich, handsome brown. It's an increasingly popular partner for pink — the result is a harmonious combination of tender, feminine attention and professional chic. Together, the colors communicate style and dignity, but with a gentle nod to the unique condition of maternity.

DESIGNER: LISKA + ASSOCIATES **CLIENT:** ME&B

		0-2	4-6	8-10	12-14	16-18
pre-pregnancy size		XS	S	M	L	XL
me&b. maternity size						

SIZE CHART

...nge, your style doesn't have to.

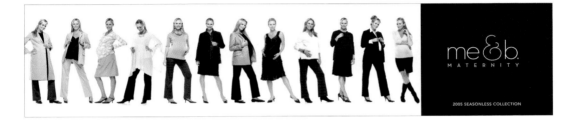

2005 SEASONLESS COLLECTION

FIREBRAND

HOT INVESTMENT

Firebrand is an activist venture capital (VC) firm that seeks investment opportunities in publicly-traded small-cap companies. In essence, they invest in underperforming companies in which they recognize greater potential. For Firebrand, investment means not only infusing cash, but also investing time and intellectual resources — placing people on the board, bringing in an advisory team, and offering strategies to increase profit. Firebrand's leaders are veterans of the VC world, and when they joined forces to create a new company, they turned to the San Francisco design firm NOON to forge their identity.

Firebrand takes a more aggressive approach than a typical VC firm. They are small, focused, and highly strategic. As NOON's creative director, Cinthia Wen explains, "There is no subtlety in the goals of financial investment; they are very clear and very ambitious." The colors reflect that same attitude — bold, powerful, and very much to the point. The designers at NOON explored a wide range of color options (some of which are pictured opposite), but ultimately,

felt that the mark — a flaming phoenix — was best supported by the use of a powerful, energetic color.

"How the color and the icon work together is very important," says Cinthia, reflecting on some of the cooler color options she considered. "Any other color, in the context of this design, would be misleading; it would totally shift the metaphor. If we had used blue with the bird, the logo could easily be mistaken for health care. If we used green, it would look environmental. Yellow could have worked, but it felt too soft, too playful, and a little childlike."

In the end, it was a mix of red and orange that provided the most appropriate solution. The mark's use of orange helps make it accessible, while red imbues it with power and intensity. The transition mimics Firebrand's purpose — to identify potential and then realize that potential. Translated to color: moving from warm to hot.

DESIGNER: NOON CLIENT: FIREBRAND

ROYAL CEYLON™

YOUR PERFECT CUP OF TEA

ROYAL TEA

A hole in Australia's market for high-quality tea brands led Sri Lankan's Royal Ceylon to approach the Sydney design boutique Gwarsh about developing a brand for their line of premium teas. Royal Ceylon has a rich history of offering the highest-quality brand Ceylon tea; this tradition, rooted in their long-standing commitment to quality, formed the foundation for their identity of this upscale brand.

The mark itself is executed in a unique tint of gold. Not the bright, yellow-gold of capital domes, trophies, and 24-karat jewelry, it is instead a slightly subdued hue—evoking richness without needing to prove itself. In most applications, however (including the all-critical packaging), the mark reverses to white, allowing the surrounding colors to present the brand character. Flavors of tea served as inspiration for choices of red, royal blue, rich green and gold. The colors not only act as a clue to the flavor of each product, they also exude a sense of taste, grace, and sophistication—even a sense of majesty that reaches back into tradition.

For thousands of years, the royal class has been represented by these colors—their status distinguished by opulent hues that create a commanding air of power, prestige and elegance. To be royal is to be rich in all aspects; the colors are indulgently saturated without being overwhelming or garish, suggesting a luxurious lifestyle that is central to this type of premium brand.

This is a case in which color shapes the entire feeling and experience of the brand; the color story *is* the brand story. It is at once assertive and attentive, practical and emotional, regal yet approachable. It is traditionally rooted, but forward-looking. In sum, it assumes a position of leadership in what is already a leadership segment.

DESIGNER: GWARSH **CLIENT:** ROYAL CEYLON

SUPERHERO HUES

Every period has its signature colors and color combinations. So when Device's Rian Hughes was commissioned to design a logo for a collection of 1950s space-themed comic strips (assembled from the archives of DC Comics), he took his cues from the hues of the era.

In comics, says Rian, "the '80s might be character-ized by red, yellow, and gray, while the '60s and early '70s can be evoked with day-glo inks in orange and purple." For this project, he drew on '50s colors he describes as "cream, oxblood, and eau de Nile." Combined, they create a classic hot/cool color combination that creates both drama and harmony. Rian also employed a few other color tricks to help achieve an authentic effect.

For one thing, there is no solid black in the logo. Some very old pulp covers saved on print costs by dropping the black plate (so the darkest color they could achieve was 100C, 100M, 100Y). Rian mim-icked this effect in the logo, creating a softer, vintage feel. He also avoided using gradients and other

contemporary effects, instead favoring bright, flat colors. Rian was also careful to maintain readability by avoiding placing tonally similar colors next to each other. Because "space" was the most important word in the title, he made sure that came forward by selecting a color that clashed with the surrounding background colors.

DESIGNER: DEVICE CLIENT: DC COMICS

Opposite:
While each of the color combinations Rian explored has a unique and authentic character, ultimately the most muted palette prevailed

131

ENERGETIC

What it's about:

Those with energy never stop moving, playing, or dreaming. Typically competing against each other in the aisles of toy stores, energetic colors reinforce the youthful exuberance of childhood. Red-purples, greens, and yellows help products spring to life and call for attention. An energetic color scheme limits the inclusion of dull counterparts, while retaining a strong contrast among vibrant hues. Fuchsia on its own is perceived as very active, but can lose its effect when combined with clashing greens or yellows.

What it's good for:

Childrens' toys
Energy drinks
Athletic shoes and apparel

What to look out for:

Too many energetic colors can confuse the viewer and seem childish. Also, don't confuse energetic colors with primary or highly-saturated colors.

1 DESIGNER: ADAMSMORIOKA, INC. CLIENT: THE NATIONAL NETWORK
2 DESIGNER: CRE8 COMMUNICATIONS, INC. CLIENT: CRE8 COMMUNICATIONS, INC.
3 DESIGNER: ADAMSMORIOKA, INC. CLIENT: DISNEY CLUB HOUSE

1 The National Network

2

3

M 92, 94 M 90, 95 M 90, 92, 96 M 89, 91, 93

M 91, 92, 95 T 28, 60, 92 T 25, 61, 96 T 29, 59, 96

T 31, 60, 91 C 44, 92 C 42, 92 C 43, 93

C 45, 96 C 41, 90 A 76, 84, 92 A 78, 88, 92

SEE PROCESS COLOR CHART ON PAGE 152 FOR CMYK VALUES

A = ANALAGOUS C = COMPLEMENTARY CL = CLASH M = MONOCHROMATIC

N = NEUTRAL S = SPLIT SC = SPLIT COMPLEMENTARY T = TERTIARY

A 79, 87, 91

A 3, 83, 92

A 4, 86, 95

A 5, 87, 90

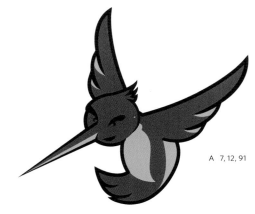

A 7, 12, 91

A 6, 10, 94

A 2, 13, 96

SC 36, 52, 92

SC 34, 54, 92

SC 39, 55, 92

SC 36, 52, 89

SC 40, 50, 96

SC 36, 49, 90

SC 36, 54, 93

S 36, 49, 93

S 37, 55, 92

S 33, 49, 90

S 37, 53, 92

CL 52, 92

CL 54, 94

CL 49, 94

CL 49, 91

CL 36, 92

CL 35, 94

CL 33, 91

N 41, 89

N 89, 92

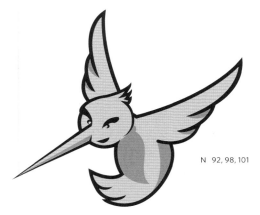

N 92, 98, 101

N 92, 99, 102

N 92, 98, 100

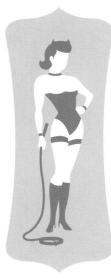

SULTRY

What it's about:

Sometimes the best way to get people to listen is to whisper. Typically found on products designed for women, sultry color schemes carry a message of femininity and sweet seduction. This scheme favors colors from a softer spectrum that includes lighter hues with a wider range of grays. Lavender is the soft-spoken representative of this color scheme, reminiscent of fragrant powders, intimate interiors, and quiet moments. Those seeking a sultry color scheme should do so with kind and sweet intentions.

What it's good for:

Beauty products
Organic products
Women's merchandise

What to look out for:

Subdued colors can easily blend together and become a muddy mess, so beware of how you combine them.

1 **DESIGNER:** GARDNER DESIGN **CLIENT:** VIRTUAL FOCUS

2 **DESIGNER:** SIBLEY PETEET DESIGN **CLIENT:** MARY KAY COSMETICS

3 **DESIGNER:** ADDIS **CLIENT:** AURA CACIA

1

MARY KAY

2

AURA CACIA.

3

M 94, 96

M 92, 94

M 91, 94

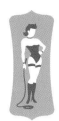

M 93, 95

M 92, 94, 96

M 89, 92, 95

M 90, 94, 96

M 94, 95, 96

T 26, 59, 95

T 30, 62, 94

T 31, 62, 93

T 32, 63, 95

C 46, 94

C 48, 94

C 42, 95

C 45, 93

SEE PROCESS COLOR CHART ON PAGE 152 FOR CMYK VALUES

A = ANALAGOUS C = COMPLEMENTARY CL = CLASH M = MONOCHROMATIC

N = NEUTRAL S = SPLIT SC = SPLIT COMPLEMENTARY T = TERTIARY

C 43, 90

C 42, 95

C 47, 91

A 78, 86, 94

C 48, 96

A 80, 85, 90

A 75, 86, 94

A 6, 86, 94

A 8, 85, 95

A 5, 88, 95

A 7, 86, 92

A 7, 16, 95

SC 38, 56, 94

SC 38, 54, 93

SC 38, 51, 91

SC 35, 55, 95

SC 34, 50, 96

S 35, 50, 94

S 39, 54, 94

S 40, 55, 95

S 35, 94, 96

SC 34, 54, 93

CL 54, 94

CL 53, 91

CL 35, 93

N 33, 95

N 35, 95

N 34, 96

N 94, 98, 100

N 93, 98, 101

PROFESSIONAL

What it's about:

Neither overly enthusiastic nor dispassionately subtle, professional color palettes speak of trust and sincerity. Its pure hues are lightened and darkened simultaneously, creating an atmosphere of maturity and experience. Gray acts as the accenting color in this scheme due to its ability to soften intense colors while darkening the entire palette. Being a versatile, neutral color helps gray fit into any application in need of an upscale twist.

What it's good for:

Professional services

Conservative establishments

Technology industry

What to look out for:

Mixing professional colors with more saturated hues can make the color scheme appear dirty.

1 **DESIGNER:** MITRE DESIGN **CLIENT:** NANO-TEX, INC.

2 **DESIGNER:** EISENBERG AND ASSOCIATES **CLIENT:** SILVER SPUR RANCH

3 **DESIGNER:** WEBSTER DESIGN ASSOCIATES INC. **CLIENT:** FIRST NATIONAL BROKERAGE

1 2 3

98, 100, 101

98, 99, 101

97, 99, 100

99, 102, 104

100, 104, 105

99, 102, 103

97, 99, 106

98, 101, 105

2, 97, 98

3, 98, 100

4, 97, 104

5, 8, 101

12, 97, 100

14, 97, 99

10, 97, 99

20, 99, 102

SEE PROCESS COLOR CHART ON PAGE 152 FOR CMYK VALUES

23, 98, 101

22, 99, 102

29, 97, 98

31, 100, 102

28, 97, 100

27, 98, 99

36, 97, 98

39, 99, 104

35, 97, 105

38, 101, 102

49, 97, 99

48, 98, 101

52, 97, 99

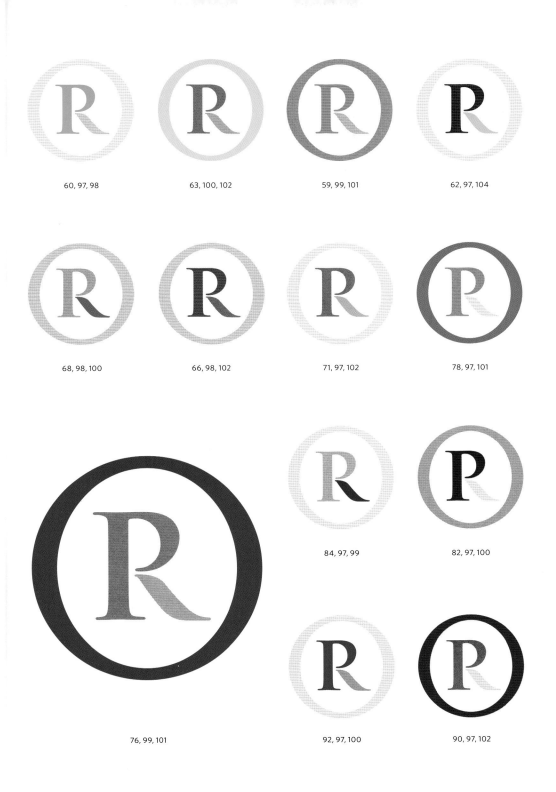

60, 97, 98

63, 100, 102

59, 99, 101

62, 97, 104

68, 98, 100

66, 98, 102

71, 97, 102

78, 97, 101

76, 99, 101

84, 97, 99

82, 97, 100

92, 97, 100

90, 97, 102

PURE

What it's about:

Like the unblemished landscape of freshly fallen snow or the cascading fluidity of a wedding dress, white is the symbol of purity. Color schemes placed in this category are light in tone; exhibiting a clear, but less intense resemblance to its most saturated hue. Honest and unblemished, pure colors exude the essence of color and light without being overly aggressive or complex.

What it's good for:

Health and wellness
Bed and bath products
Products for infants

What to look out for:

Too little color can create a washed-out look that lacks authority.

1 DESIGNER: PAT TAYLOR INC. CLIENT: MAGNA-CHECK CORPORATION
2 DESIGNER: DEVICE CLIENT: THE SOURCE
3 DESIGNER: BBK STUDIOS CLIENT: CENTRAL MICHIGAN PAPER

1 2 3

106

96

8

7, 8

15, 16

23, 24

31, 32

13, 29

53, 64

77, 87

48, 95

7, 56

16, 67

24, 71

32, 80

40, 88

SEE PROCESS COLOR CHART ON PAGE 152 FOR CMYK VALUES

47, 95

8, 55

31, 39

22, 32

24, 40

24, 30

30, 39

40, 47

32, 47

31, 38

47, 55

38, 54

39, 75

46, 48

39, 93

40, 80

39, 94

80, 96

78, 96

79

38

70

72, 78

69, 72

71, 78

71, 97

72, 101

67, 100

68, 99

GRAPHIC

What it's about:

Instant information is the main objective of graphic color schemes. Simple and direct, these combinations are bold and assertive. Dramatic contrast is imperative to a graphic color scheme. Black is the definitive color of choice because of its dark tone and neutrality amongst other colors. An extremely versatile color, it is used in the majority of logos (largely for its utility as a text color as well).

What it's good for:

Creative professionals
Extreme sport industry
Night clubs
Software companies
Anyone not afraid to be noticed

What to look out for:

Overuse of black suggests a lack of character and can be construed as a budget constraint rather than a strategic decision. Color schemes that are too graphic may be so assertive they border on obnoxious.

1 DESIGNER: HOWALT DESIGN STUDIO, INC. CLIENT: LOT 44
2 DESIGNER: HOWALT DESIGN STUDIO, INC. CLIENT: WORK, INC.
3 DESIGNER: SANDSTROM DESIGN CLIENT: FILMCORE

1 2 3

103, 105, 106

103, 104, 106

98, 106

1, 7, 106

9, 15, 106

17, 23, 106

25, 31, 106

33, 37, 106

41, 45, 106

49, 53, 106

57, 61, 106

65, 69, 106

73, 77, 106

81, 85, 106

89, 93, 106

20, 106

SEE PROCESS COLOR CHART ON PAGE 152 FOR CMYK VALUES

36, 106

52, 106

4, 52, 106

12, 60, 106

4, 106

36, 84, 106

28, 68, 106

36, 92, 106

20, 60, 106

12, 68, 106

36, 76, 106

28, 84, 106

52, 92, 106

68, 92, 106

92, 106, 107

12, 106

78, 106

12, 68, 106

72, 106

64, 106

40, 106

16, 106

78, 106

process color chart

COLOR NUMBER	C	M	Y	K
1	0	100	100	45
2	0	100	100	25
3	0	100	100	15
4	0	100	100	0
5	0	85	70	0
6	0	65	50	0
7	0	45	30	0
8	0	20	10	0
9	0	90	80	45
10	0	90	80	25
11	0	90	80	15
12	0	90	80	0
13	0	70	65	0
14	0	55	50	0
15	0	40	35	0
16	0	20	20	0
17	0	60	100	45
18	0	60	100	25
19	0	60	100	15
20	0	60	100	0
21	0	50	80	0
22	0	40	60	0
23	0	25	40	0
24	0	15	20	0
25	0	40	100	45
26	0	40	100	25

COLOR NUMBER	C	M	Y	K
27	0	40	100	15
28	0	40	100	0
29	0	30	80	0
30	0	25	60	0
31	0	15	40	0
32	0	10	20	0
33	0	0	100	45
34	0	0	100	25
35	0	0	100	15
36	0	0	100	0
37	0	0	80	0
38	0	0	60	0
39	0	0	40	0
40	0	0	25	0
41	60	0	100	45
42	60	0	100	25
43	60	0	100	15
44	60	0	100	0
45	50	0	80	0
46	35	0	60	0
47	25	0	40	0
48	12	0	20	0
49	100	0	90	45
50	100	0	90	25
51	100	0	90	15
52	100	0	90	0

COLOR NUMBER	C	M	Y	K
53	80	0	75	0
54	60	0	55	0
55	45	0	35	0
56	25	0	20	0
57	100	0	40	45
58	100	0	40	25
59	100	0	40	15
60	100	0	40	0
61	80	0	30	0
62	60	0	25	0
63	45	0	20	0
64	25	0	10	0
65	100	60	0	45
66	100	60	0	25
67	100	60	0	15
68	100	60	0	0
69	85	50	0	0
70	65	40	0	0
71	50	25	0	0
72	30	15	0	0
73	100	90	0	45
74	100	90	0	25
75	100	90	0	15
76	100	90	0	0
77	85	80	0	0
78	75	65	0	0
79	60	55	0	0

COLOR NUMBER	C	M	Y	K
80	45	40	0	0
81	80	100	0	45
82	80	100	0	25
83	80	100	0	15
84	80	100	0	0
85	65	85	0	0
86	55	65	0	0
87	40	50	0	0
88	25	30	0	0
89	40	100	0	45
90	40	100	0	25
91	40	100	0	15
92	40	100	0	0
93	35	80	0	0
94	25	60	0	0
95	20	40	0	0
96	10	20	0	0
97	0	0	0	10
98	0	0	0	20
99	0	0	0	30
100	0	0	0	35
101	0	0	0	45
102	0	0	0	55
103	0	0	0	65
104	0	0	0	75
105	0	0	0	85
106	0	0	0	100

contributors

ADAMSMORIOKA, INC.
323.996.5990
adamsmorioka.com

ADDIS
510.704.7500
addis.com

ALTERPOP
415.558.1515
alterpop.com

ASSOCIATED
ADVERTISING AGENCY, INC.
316.683.4691
associatedadv.com

BBK STUDIO
616.459.4444
bbkstudio.com

BRANDEQUITY
617.969.3150 x232
brandequity.com

CATO PURNELL PARTNERS
61 3.9429.6577
cato.com.au

CHASE DESIGN GROUP
323.668.1055
margotchase.com

CHERMAYEFF & GEISMAR, INC.
212.532.4595
cgpartnersllc.com

CRE8 COMMUNICATIONS, INC.
612.227.0908
e-cre8.com

DAVE CLARK ASSOCIATES
64.9.300.1610
daveclark.co.nz

DEVICE
44.20.7221.9580
devicefonts.co.uk

DESIGN AND IMAGE
303.292.3455
d-and-i.com

DOGSTAR
205.591.2275
dogstardesign.com

DOTZERO DESIGN
503.892.9262
dotzerodesign.com

EISENBERG & ASSOCIATES
214.528.5990
eisenberg-inc.com

GARDNER DESIGN
316.691.8808
gardnerdesign.com

GLITSCHKA STUDIOS
503.581.5340
glitschka.com

GWARSH
61.411.226.467
gwarsh.com

HENDERSON TYNER
ART COMPANY
336.748.1364
hendersonbromstead.com

HORNALL ANDERSON
DESIGN WORKS
206.467.5800
hadw.com

HOWALT DESIGN STUDIO, INC.
480.558.0390
howaltdesign.com

INTERBRAND
212.798.7500
interbrand.com

JAMES LIENHART DESIGN
312.738.2200
lienhartdesign.com

JOE BOSACK DESIGN
215.766.1461
joebosackdesign.com

JOHN EVANS DESIGN
214.954.1044
johnedesign@aol.com

KELLUM MCCLAIN INC.
212.979.2661
kellummcclain.com

KEN SHAFER DESIGN
206.223.7337
kenshaferdesign.com

KIKU OBATA & COMPANY
314.361.3110
kikuobata.com

LANDOR ASSOCIATES
415.365.1700
landor.com

LISKA + ASSOCIATES
312.644.4400
liska.com

MANIC DESIGN
6324.2008
manic.com.sg

MINE™
415.647.6463
minesf.com

MIRES>DESIGN FOR BRANDS
619.234.6631
miresbrands.com

MITRE DESIGN
336.722.3635
mitredesign.com

MLS CREATIVE SERVICES
212.450.1258
mlsnet.com

MODERN DOG COMMUNICATIONS
206.789.7667
moderndog.com

NOON
415.621.4922
designatnoon.com

ORANGE
07973.100.345
orange.co.uk

PAT TAYLOR, INC.
202.338.0962

PLANET PROPAGANDA
608.256.0000
planetpropaganda.com

PLUMBLINE STUDIOS
707.251.9884
plumbline.com

PREJEAN LOBUE
337.593.9051
prejeanlobue.com

RANDY MOSHER DESIGN
773.973.0240
randymosherdesign.com

RICKABAUGH GRAPHICS
614.337.229
rickabaughgraphics.com

RICHARDS BROCK MILLER MITCHELL & ASSOCIATES
214.987.6500
rbmm.com

SABINGRAFIK, INC.
760.431.0439
tracy.sabin.com

SANDSTROM DESIGN
503.248.9466
sandstromdesign.com

SAYLES GRAPHIC DESIGN INC.
515.279.2922
saylesdesign.com

SIBLEY PETEET DESIGN
512.473.2333
spdaustin.com

SIMON & GOETZ DESIGN
49.0.69.9688550
simongoetz.de

SOLOFLIGHT DESIGN STUDIO
770.792.8645
soloflightdesign.com

SPATCHURST
61.2.9360.6755
spatchurst.com.au

STEPHEN O'CONNOR
323.779.5600
oconnorid@hotmail.com

STERLING BRANDS
212.329.4600
sterlingbrands.com

TACTIX CREATIVE
480.688.8881
tactixcreative.com

THOMAS VASQUEZ
718.422.1948
thomasvasquez.com

VERLANDER DESIGN
650.563.9247
verlanderdesign.com

WAGES DESIGN
404.876.0874
wagesdesign.com

WEBSTER DESIGN ASSOCIATES, INC.
402.551.0503
websterdesign.com

WOW! BRANDING
604.683.5655
wowbranding.com

about the authors

MINE was founded with the philosophy that good design is good business, and that working smart beats working big. A multidisciplinary studio, MINE offers innovative and informed solutions as tools to support corporate, enterprise, and nonprofit organizations. Emphasizing intelligence-based design and sound strategic thinking, MINE seeks to create definitive, stand-out work that projects a unique position of leadership and promotes the highest standards of excellence.

Christopher Simmons is a designer, writer, and educator and the founding creative director of MINE™, a multi-disciplinary design office located in San Francisco. His passion and interest in exploring the increasingly complex notion of identity has lead him to develop and teach courses on the subject at the California College of the Arts and San Francisco's Academy of Art University. An advocate for the power of design, he also lectures at colleges, universities, and professional associations on topics ranging from collaborative work models and the role of language in graphic design to issues of professional, ethical, and sustainable practice. His first book, *Logo Lab*, was released in June 2005.

Christopher is the president of the San Francisco chapter of AIGA, the professional association for design.

Tim Belonax is a graduate of the Rhode Island School of Design (RISD) and a former Chronicle Books fellow. Before joining MINE, Tim worked for top advertising and packaging design firms in San Francisco and Beverly Hills, where he brought his talents to bear on such consumer brands as Trident White, Cornuts, and Beefeater Gin. An experienced silk-screen printer, Tim's passions include ice hockey, cooking, and dental hygiene. He is a member of AIGA.

Kate Earhart is an upper-division student at the Academy of Art University, where she is pursuing her second degree (her first is in psychology, with a minor in photography). A competitive rock climber, Kate speaks Spanish, Italian, and Ukrainian. She does not yet speak Chinese, but she's confident she can pick it up. She is a member of AIGA.

thanks

Those without whom this book would
not be possible, and why:

Tim Belonax
Designer, Writer, Fighter

Kate Earhart
Writer, Sketcher, Fetcher

Nancy Hseih
Seeker, Finder

Kristin Ellison (Rockport)
Editor, Faith Healer

Betsy Gammons (Rockport)
Mover, Shaker

Regina Grenier (Rockport)
Coordinator, Advancer